This poem is not
comp...

but of the effusive viscera...

of an endless
cacaphony
...of memories

typewriter
rodeo

This poem is not

simply telling a story

but unraveling three other stories

in reverse

esrever ni?

This poem

doesn't care if you read it

It's already read you

Andrews McMeel Publishing
a division of Andrews McMeel Universal
1130 Walnut Street,
Kansas City, Missouri 64106

www.andrewsmcmeel.com

18 19 20 21 22 SDB 10 9 8 7 6 5 4 3 2 1

ISBN: 978-1-4494-8700-3

Library of Congress
Control Number: 2017959257

Editor: Patty Rice

Art Director/ Designer: Diane Marsh

Production Editor:
David Shaw

Production Manager:
Cliff Koehler

typewriter rodeo

Real people, real stories, custom poems

Jodi Egerton * David Fruchter * Kari Anne Holt * Sean Petrie

Andrews McMeel
PUBLISHING®

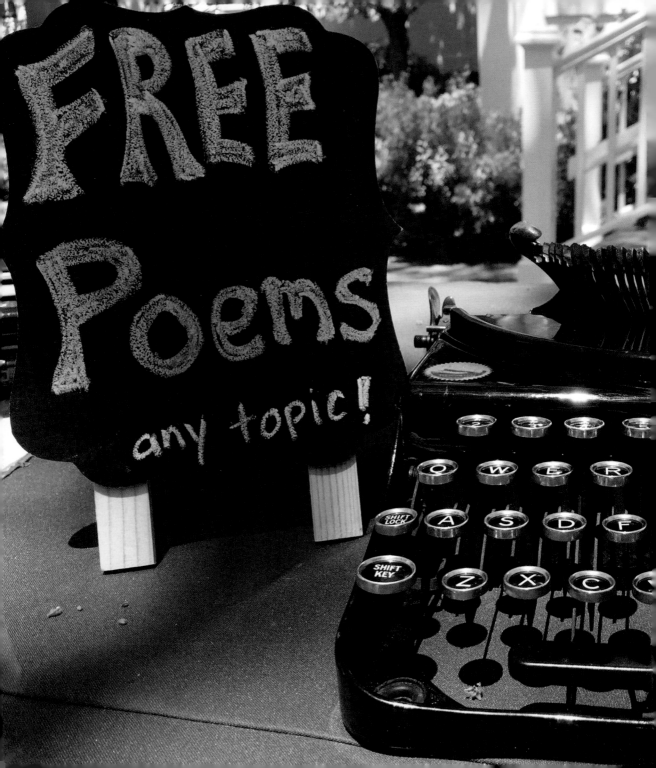

CONTENTS

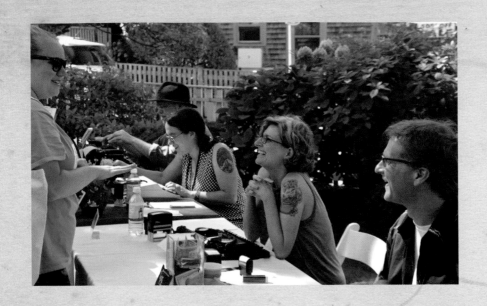

"SO WHAT IS IT,
EXACTLY,
THAT YOU'RE
DOING HERE?"

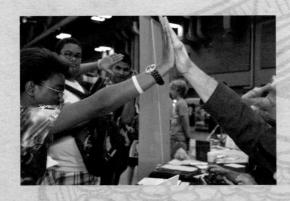

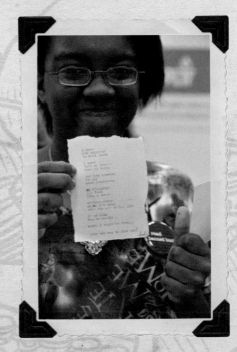

"WE'RE WRITING SPONTANEOUS POETRY. GIVE US A WORD, A PHRASE, ANY TOPIC YOU WANT, AND WE'LL TURN IT INTO A POEM FOR YOU, RIGHT HERE, RIGHT NOW."

This is how most of our interactions begin. A simple question and a simple answer. Four poets sit behind four vintage typewriters, and we're there for one reason: to write you a free poem about whatever you want. Often, the person requesting the poem isn't sure what to make of us. They don't know if they even *like* poetry, and they can't think of a topic. Just as often, people are incredibly enthusiastic. They know *exactly* what they want a poem about, and have several topics. And the number one thing these two camps have in common? When they get their poems they are amazed, delighted, moved to laughter or tears. They offer us high-fives, shoulder squeezes, hugs. They wonder out loud if we're poets or fortune tellers.

What we really are, though, is a quartet of observers. Our poems aren't written to be stand-alone masterpieces, they're meant to capture a time and a place and a question: What do you want *your* poem to be about today?

In the brief shared moment of question, answer, poem request, poem creation and poem delivery, there is a spontaneous spark that brings us together.

We *see* you, really see you. And then we never see you again.

Therein lies the beauty of Typewriter Rodeo, and the beauty of spontaneous poetry as an art form. It's poetry about you, for you, in this moment, right now. A photograph of verse, in a way. And so to share those moments of art with you, we've compiled some of our favorite stories and poems in a book celebrating not just poetry, and the magic spontaneity of typewriters, but also human nature, and maybe most important of all . . . human connection.

Austin Mini Maker Faire® Meet the Makers

The Word Makers!

You give us a challenge, we will write you a poem or story on the spot!

KARI ANNE

BIRTH OF THE RODEO

The number one question we get is: How did you guys come up with this idea? How was Typewriter Rodeo born?

Typewriter Rodeo was born when Jodi wanted a booth at Austin's first Maker Faire in 2013. If you aren't familiar with it, Maker Faire is a celebration of arts, engineering, and everything that is part of the do-it-yourself Maker movement. It was created in the Bay Area in 2006, and by 2013 a group of people had gotten together to hold one in Austin, Texas. Friends with the organizers, Jodi wanted in on it. The problem was, with a PhD in English, she wasn't sure what exactly she would *make*. Maybe . . . words? But how would that work?

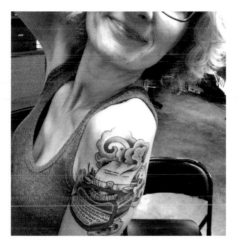

Jodi put out a call to find some Word Makers. Sean, David, and I answered the call. Then came brainstorming. Maybe the Word Makers could create short stories and hand them out. Or maybe poetry. I had been collecting typewriters for a few years and offered to bring some for the booth, because that would be fun, right? It would add a little something to the stories or the poetry or whatever was created.

Maker Faire began, and the Word Makers had their booth. A crowd formed as the typewriters clacked. Poems were customized and shared. The crowd grew. More poems were written. The crowd grew even bigger. At one point someone in line shouted, "It's like a Typewriter Rodeo!" And at another point someone asked if we did this at other events. It took one beat of eye contact before there was a unanimous, "Of *course* we do!"

We typed side-by-side for eight (!) hours that day. By that evening the TypewriterRodeo.com domain had been purchased, and we were off to the races.

SEAN

OUR FIRST POEM

Like Kari Anne said, we had almost no idea what we were doing the day we started. Our sign simply said: "You give us a challenge, we will write you a poem or story on the spot!"

Kari Anne and I were the first to arrive at our table that morning. I sat down behind one of her typewriters and waited. After a while a girl came up, probably nine or ten years old, and asked for a poem about dragons. Our first request ever!

Kari Anne and I looked at each other, and I said something like, "I can do it." I was nervous. But this little girl was standing there, waiting for her poem. So I decided to do a haiku, since they are so short. I typed it out, then read it aloud.

Kari Anne snapped a photo as I did, and at least for some reason (maybe the poem, maybe my hair), the girl was smiling. I also took a quick photo of that poem.

For that first day, and a few gigs after, we stuck to haikus; once we got a bit more settled into our groove, we flexed our poetry muscles and moved on to full-length poems. We still do haikus, but usually only if there's a specific request for one; I'd guess that happens less than 1 percent of the time. Here's what we think is our second-ever poem, a haiku by Kari Anne:

it is boiling hot
as I stand here in the sun
and think of your face

Kari

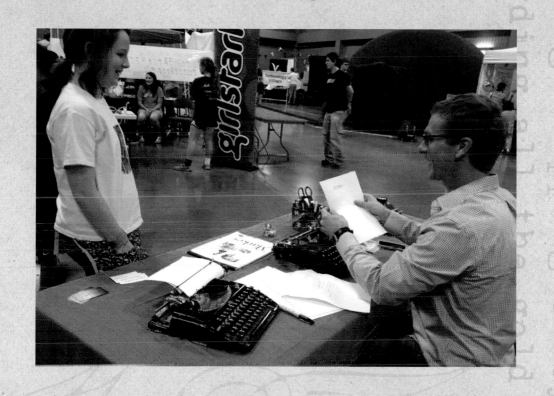

smoky fire nostrils
soaring flappingscaley bird
guarding all the gold

JODI & DAVID

OPENING DAY

JODI:

We arrived at Austin Maker Faire with low expectations—we'd write a few poems for people, peck around on the typewriters some, spend a fun day together making words, and then part ways, satisfied to have crafted a chance to play and write together. I figured we'd trade off—one of us writing while the others poked around the Faire.

But once we got going, two things happened—people flocked to the sound of the typewriters, and we found ourselves with a line. A long line. We had a whole collection of Kari Anne's antique typewriters, so we quickly put them all into action, typing away.

On we typed, fingers flying, ribbons jamming. These typewriters weren't quite maintained enough to tackle the endless poems we were writing, so we had inky fingertips and jammed pinkies and sore elbows from all the wrassling with stuck keys. But we typed, and typed, and typed. The energy was infectious. As the hours passed, we got more enthusiastic, more delighted at the magic taking place. We laughed, we high-fived each other, and over the course of that day, we discovered what it felt like to become Typewriter Rodeo.

DAVID:

I'd only met Jodi maybe a month before we all got together, when I took a writing and improv workshop class she taught. Then, when she asked if I wanted to join her and some friends to make up stories and poems at the Austin Maker Faire, I didn't hesitate. From that first day, there was a magic about the whole thing—not just writing poems for people on the spot, but from the four of us, doing it together. There's something special about having your typin' buddies at your side,

hearing them clacking away next to you, literally *feeling* the energy of their poem creation. And I think everyone else—guests, poem recipients, passersby—enjoyed the interactive experience so much more that way, rather than if it had been just one of us typing solo. As we like to say, "It takes two to Rodeo." We're a team. That's been our thing from day one, and what makes this so special for me. And what continues to make this the most fun job I've ever had.

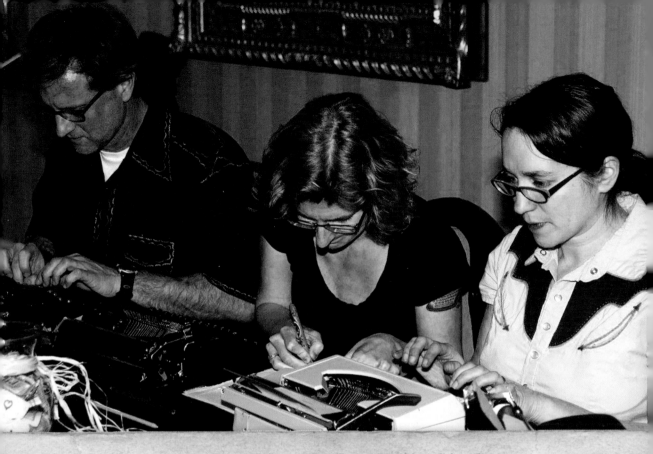

the NITTY-
GRITTY
of poem-typing

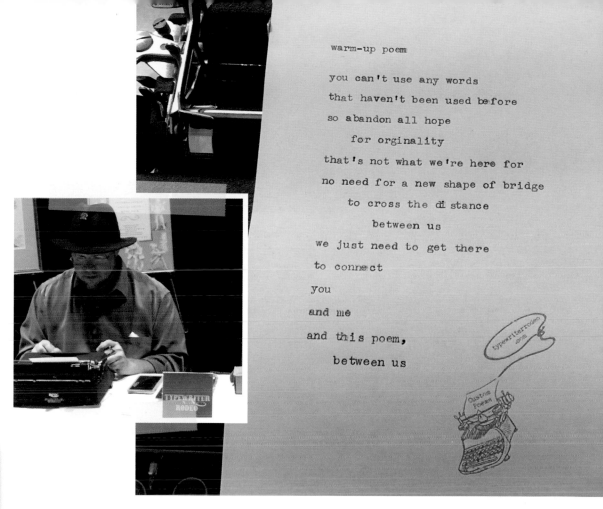

warm-up poem

you can't use any words
that haven't been used before
so abandon all hope
 for orginality
that's not what we're here for
no need for a new shape of bridge
 to cross the distance
 between us
we just need to get there
to connect
you
and me
and this poem,
 between us

DAVID

WARMING UP BEFORE A GIG

Sitting at my typewriter for the first time all day, after we've set up at a gig but before the crowds have started to gather, I'll frequently type a quick (and usually quite silly) warm-up poem just to get the juices flowing. Sometimes these actually come out rather well;

this is one I particularly enjoyed writing. (One motif that tends to recur in the warm-up poems, for me, is advice for myself about the task that's about to get underway; I hope it might be useful to any other writers who are reading this book!)

JODI
THE PROCESS OF PLAY

Once we're set and ready for a gig to start, we all take a deep breath and trust in the process.

We often turn to the foundational tenets of improvisation as we start a poem—say yes to your ideas, take risks, embrace the power of play.

No two poems are the same—even when we've tackled the same topic before (sometimes hundreds of times). There's a bit of magic that happens when we start a poem that leads us inevitably down a whole new path.

We're serious about our work, but we also don't take *ourselves* too seriously. We have fun, we dance with language, we sling rhymes and play with references. We surprise ourselves as we write—I often liken it to going into a zone and just letting the energy of the moment drive the poem.

One finger landing on the wrong letter will start the poem down a whole new trajectory. Instead of "This" I'm writing "Trust" and instead of going back and correcting it, I say yes and move forward through the poem. We follow the mistakes and play with the unexpected. The poems that we share at the end are often as much a surprise to us as they are to the recipient.

Lynch

This poem is not
 composed of words

 but of the effusive viscera.

 of an endless
 cacaphony
 of memories

This poem is not

 simply telling a story

 but unraveling three other stories

 in reverse
 esrever ni?

This p o em
 doesn't care if you read it

 It's already read you

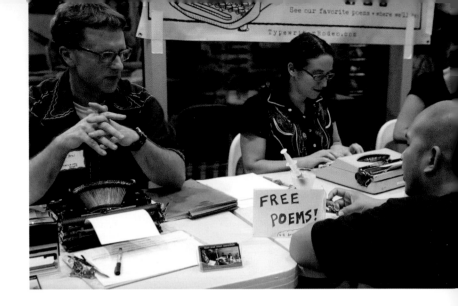

SEAN

POEMS FOR STRANGERS

The vast majority of our poems are created from spontaneous interactions between strangers: Someone we've never met comes up to our table and gives us a topic, ideally we share a moment of connection, and then they leave. And we never see them—or their poem—again.

For a few poems, we'll take a quick photo before it's gone forever. Perhaps we like that particular poem for some reason, or perhaps we're drawn to that particular person's story. But even though we have the photo, we still have no idea who the poems ended up with once they leave our table.

At the 2015 Austin Maker Faire, we had a long line. About halfway through the day, a man came up for his poem and told me: "My partner wants to have kids, I don't. We've been together eight years, but now we're splitting up. Nothing's wrong, we just . . . can you put that in a poem?"

Even though it's not uncommon for someone to share highly personal stories with us, I'm still a bit awestruck each time: This is a complete stranger, trusting me to craft something so intimate and vulnerable into a poem.

When I start a poem like that—any poem, really—sometimes I have a glimmer of where the poem will go; other times I just latch onto whatever pops into my head and run with it. With this poem, the image of binary stars immediately came up, and I started typing.

When I finished, I snapped a photo of the poem and handed it over to the man, who had stood there quietly the whole time. We were so busy, I went right to the next person in line; like so many of our poems, I never got to see him read it, never saw him again.

NOTHING'S WRONG

Have you ever heard
Of binary stars?
It happens when two points of light
Two bright-burning bodies
Are so drawn together
That they become encircled
A pair
Orbiting around each other in perfect
Balance.

But not forever.
~~Buck~~ Because sometimes it's
a small shift
Maybe a nanosecond break
in gravity
Maybe a miniscule meteor
from nowhere
And those two stars
That forever pair
Suddenly
Split.
And it's not because anything
Is wrong
Or bad
It's just that the universe says
It's time.

—Sean

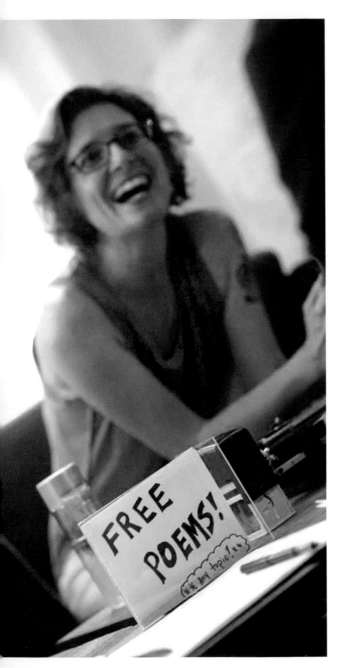

FREE POEMS! (or any topic!)

KARI ANNE
TOUGHEST TOPICS

When we're typing at a gig, one of the questions that invariably comes up is: what are your most difficult poem requests? A standard answer we all give is that the vague topics are a little tougher than others. Something like "love" is not always easy, because we want more details.

Secretly, though, the most difficult topic for me is often typewriters. You'd think this topic would be easy . . . and yet . . . typewriters are an intrinsic part of my life. They are the conduits for so much: art, happiness, my ability to buy groceries. Typewriters have so much meaning, it's hard to boil it down into one poem.

And then I remember, this poem is not for me. This is a typewriter poem for the person standing in front of me. Their experience is different than mine. And while I like to bring personal experience

6

to my poems, it's crucial to remember these poems belong to someone else. The man who requested this poem told me about his typewriter collection, and how he's been using typewriters his whole adult life. We talked about the Remington his father owned, and the IBM Selectric he used at work for years before the typewriters were replaced by computers. He told me how he misses the visceral feeling of the keys and the clacks when he's at work. He admitted, though, that spellcheck and hard drives are pretty nice. And so, the poem I thought would be difficult to write became easy. It was *his* poem, not mine. That's one of the most important things to remember when you're sitting behind a table, typewriter at the ready . . . the question is *always*: "What would you like *your* poem to be about?" And the answer is *always*: "Okay! I can do that."

"Typewriters"

```
    loud banging tells a story
  of someone
 telling a story
   a ll the clicks
   and dings
   the sounds of thoughts
    hitting paper
    flying from synapses
  to brain
 to fingers
   to keys
     a kind of magical
 mystery tour
  of energy
and ideas
 smooth
     and then staccato
  all of your thoughts
     and his
     and hers
 hitting the page
  with bl unt force
     making a point
  as they literally
 make points
you can feel
   as you run your hands
 over the abused
   paper
```

typewriterrodeo.com

Custom Poems

—Kari Anne

7

DAVID
WHEN THERE'S NO TOPIC AT ALL...

Stumping us is practically impossible; there's something about the urgency of the situation, the feel of the typewriter keys, the shared energy between us poem-typers, the combination of high stakes (someone will be reading your work immediately, right in front of you) and low stakes (you'll probably never have to see the person or the poem again), that is immensely freeing as a writer, and the floodgates open wide. The closest I ever get to being stumped, though, is when a poem recipient adamantly refuses to give me a topic. "Write about whatever you want" is the hardest request of all, and we often push back against it, explaining that that's not how our process works: you want a poem, you supply the topic. Once in awhile I'll give in to such a request, though. Here is one that resulted from refusal to specify a topic. The recipient wouldn't say anything except: "I don't know, ANYTHING." What resulted turned out to be a sort of sweet love poem in the end.

"anything"

This is a poem about anything
And it's about everything, too
It might be a little about nothing at all
It's probably not about you
It might be about the way that you smile
It might be the look in your eyes
But probably not, like I said before
And poetry just never lies
I could write a poem about how I feel
Whenever you walk in the room
But this poem right here is not about that
Or about how you make my heart zoom.

Anything.

Everything.

Nothing.

...and you

- dmf

8

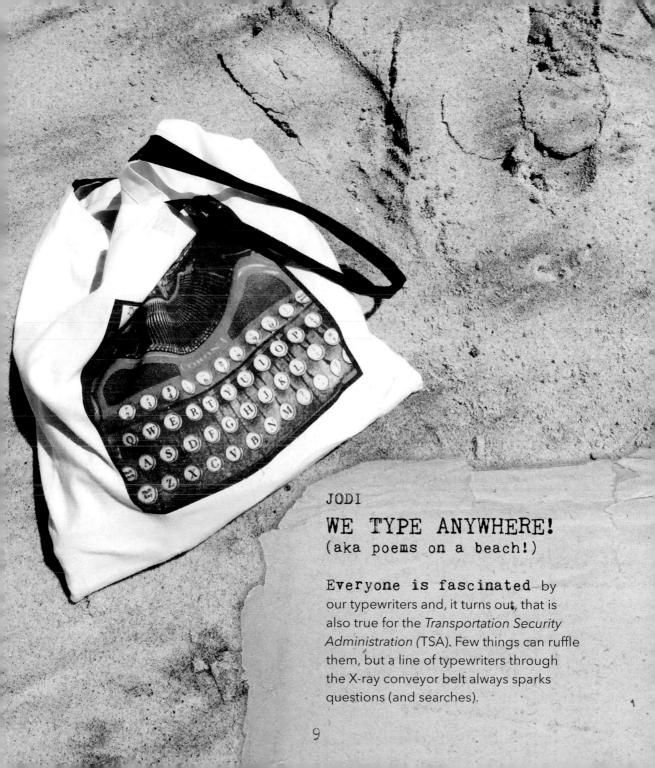

JODI

WE TYPE ANYWHERE!
(aka poems on a beach!)

Everyone is fascinated by our typewriters and, it turns out, that is also true for the *Transportation Security Administration* (TSA). Few things can ruffle them, but a line of typewriters through the X-ray conveyor belt always sparks questions (and searches).

9

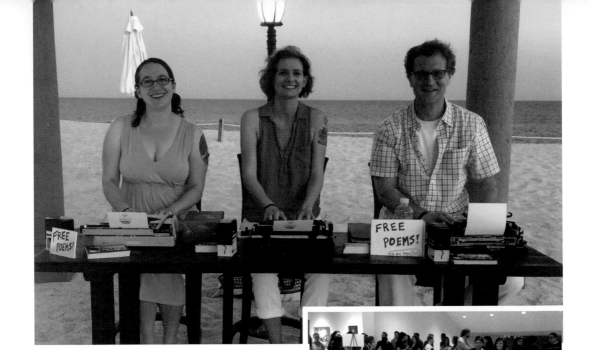

Lined up for poems
(yes, all of them!)
Dallas Museum of Art

But, oh, we love hauling our typewriters across the miles. We've typed at museums and festivals across the country, from the Nantucket Book Festival to the Perot Museum to the Smithsonian, where we typed poems at the same museum that houses the original Kermit the Frog, Dorothy's ruby slippers from *The Wizard of Oz*, and the awe-inspiring actual *Star-Spangled Banner*. And yes, we got to type on the beach in Cabo San Lucas, Mexico. I still find occasional grains of sand in my typewriter case from that memorable night.

One of the biggest crowds we had was an event at the Dallas Museum of Art. They had over ten thousand (!) visitors that day, and our poetry line stretched around the corner the whole night. And, of course, we loved it. There's something about typing poems in places that were designed to honor and share the works of artists, inventors, and creatives of all types that seems to inspire my most quirky and fun poems, like the one titled "458" that I typed that night.

10

Day 458

Today I am attempting to collapse my spine

 So that I won't trigger their

 Bone sensor

It feel s like this is something that would not
 Have even occurred to me back in my xxx old
Earthbound days.
 But up here (whereverthewhereverIam)
I have learned to stretch the boundaries of what I think

 is possible (like, aliens)
 (like, being imprisoned here)
 (like, those fruits you put up
 your nose)

And so. And. so.
 I am concentrating on my spine

 so as to turn into pudding
 so as to slip out the drain
 so as to repower the ship
 soas to fly bakk home

 where there is no zoo

 where home is home

 where i will rememberwho
 is me
 and not just be

 pudding

—jodi

SEAN
"THE MISTAKES ARE FREE"

One of the things we often hear while we're typing is, "What happens if you make a mistake?"

For me—for all of us, I think—one of the cool aspects of using a typewriter is that you can't delete, can't erase. Our machines are all old manual ones, and they don't have correcting ribbon. (My go-to is a 1928 Remington portable, which I love so much I got it tattooed on my shoulder.) We also don't use Wite-Out, or anything like that. If I happen to notice a mistake while I'm typing, I might backspace and hit a lowercase "x" over it; but most of the time I don't notice the mistakes.

So, we usually have two responses to that question: "If I make a mistake, I make a mistake! And there's no way to change it, I just keep going—kind of like life."

Then we'll add: "And, as we like to say—the mistakes are free!"

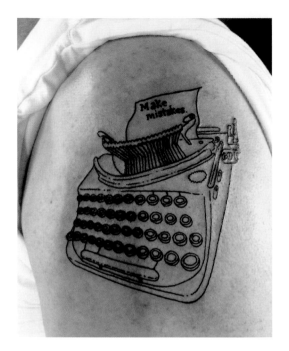

letters etched in ink
the carriage advances on
there are no mistakes

That whole concept—embracing the uncorrectable nature of typing and life—prompted my haiku above, which was in response to a local filmmaker who did a documentary on us and asked if we could write a short poem encapsulating what we do.

KARI ANNE

THE NON-VERBAL SIDE

Part of our job as poets is to meet new people and make no assumptions or judgments about them. Rather than trying to predict who they are, we let them tell us who they are. You might think their poem topic is the thing that tells us who they are, and sure, it's a hint. But more often than not, it's also their body language. It's the way their expression changes when they say the topic out loud. It's how they interact with the other people around them, and how they interact with us. When we sit in front

of our typewriters and write a poem, we aren't just using the words you give us, we're also using every little bit of *you* that we read in the small moments of watching you stand in front of us.

In 2015, Typewriter Rodeo was invited to be on *Good Morning Texas*, a morning news show that runs on WFAA in the Dallas-Fort Worth area. We were on the air live, with our typewriters, and with news anchors we'd only just met. They, of course, were sparkling with their News Anchor Personalities while

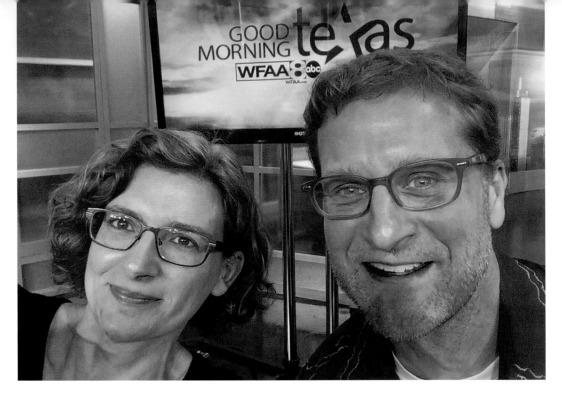

chatting with us. Everything was very much larger than life, with bright lights, blown-out colors, extra loud laughter. But in between all those things, in quiet moments where one anchor was off camera, or another was fiddling with a microphone, we were able to observe them. We watched their off-camera personalities interact, and we watched their on-camera personalities banter. So, when it was time to write poems for them, we were able to weave all facets of their relationship into the poetry. They were expecting silly haiku or basic riffs. They got a lot more than that because they *gave us* a lot more than that.

"Jane + Larry"

jane and larry
what a team
without larry
we'd never hear jane scream

without jane
larry would be so bored
the two of them
are such a score

so watch out newsroom
watch out press
Larry and Jane are a team
with whom not to mess

Custom
Poems

—Kai Ch—

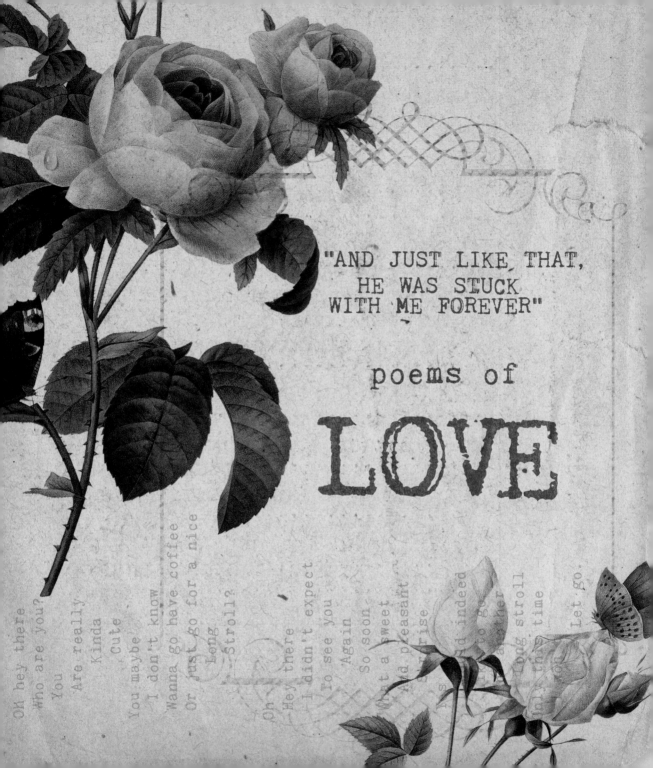

"AND JUST LIKE THAT,
HE WAS STUCK
WITH ME FOREVER"

poems of

LOVE

Oh hey there
Who are you?
You
Are really
Kinda
Cute
You maybe
I don't know
Wanna go have coffee
Or just go for a nice
Long
Stroll?

Oh
Hey there
I didn't expect
To see you
Again
So soon
What a sweet
And pleasant
Surprise
This is indeed
Nice to go
Out together
For a long stroll
In this time
Of
Let go.

LOVE NOTES

A few notes before we dive into love. (Would that we could do that with the real thing!)

First off, now that you have an overview of the Rodeo, it's time to share what it's all about—the poems. What follows are some of our favorite poems, and the stories and faces behind them, from the hundreds of gigs we've done across the country. These are real stories, shared by real people. Along with photos of the actual, unedited poems we typed for them, on the spot, in about three to five minutes.

We've loosely organized them into general topics, starting with love. Some poems are matched with their recipients, some aren't. The text accompanying the poems is either in our words (*"Poet's Note"*) or in the unedited words of the poem recipient.

How did we get these poems and stories? We take photos of every poem, every recipient, and keep a detailed database of everything we've ever done!! Um, no. . . .

In reality, the vast majority of our poems are written in a clacking flurry, handed off to the unknown recipient, and never seen again. For some, though, we'll take a photo of the poem before we let it go. Maybe it's one we particularly like, maybe it's a story we particularly want to remember, maybe it's Sean leaning over and saying, "Hey, guys, remember to take photos!" But it's a rare occurrence, having enough time and presence of mind to snap those pictures; we'd guess it happens maybe 5 percent of the time.

Other times a photo will come back to us via social media. Someone will put it on our Facebook page, or tag us on Twitter or Instagram. That's maybe another 1 to 2 percent, at best.

We also sometimes put out a mailing list signup, and we contacted those folks when compiling our book poems, so a few came from there. But overall, what you're seeing here is just the tippy-tip of the Rodeo iceberg. The vast majority of our poems are out there, floating with some unknown recipient, tens of thousands of scraps of paper, untraceable floes of words drifting around the world. We're just glad we've reconnected with these few and can share them here.

And now, on to the first topic—love!

SEAN:

AND JUST LIKE THAT,
HE WAS STUCK WITH ME FOREVER

for James Rac & Jerusha Britton

(Austin, TX)

Jerusha: James and I crossed paths online . . . and I approached him . . . and that led to our first date. We lost contact with each other for about one year and, by serendipitous circumstances, we once again crossed each other's path. After our second "first" date, we've been together ever since.

That was why when Sean asked for my poem topic, it was like a light bulb went off. The poem was to represent our modern-day love story, and this seemed like a cute, quirky way to express our relationship. I pointed to James and said: "And just like that, he was stuck with me forever."

I didn't tell Sean anything else. He smiled and nodded, clacked away for a couple minutes, then handed me the poem. After I read it, I went around the table and gave him a huge hug.

James: Jerusha showed me the poem, and I laughed at how similar it was to our beginning and present. The offsetting of the words matches how shy I am (and was) . . . and even the idea of coffee and a stroll is basically what we did for our first date. We can't help but read it and smile.

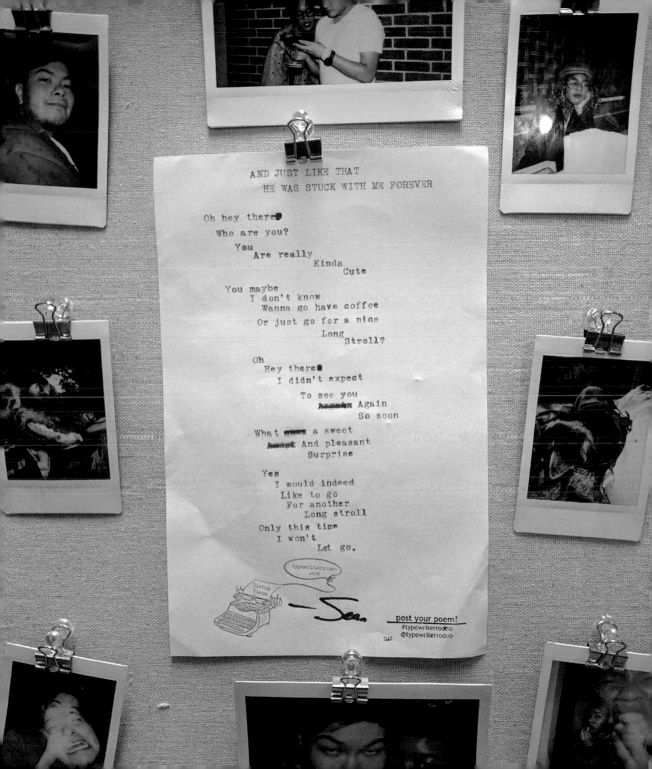

AND JUST LIKE THAT
HE WAS STUCK WITH ME FOREVER

Oh hey there

Who are you?

You
 Are really
 Kinda
 Cute

You maybe
 I don't know
 Wanna go have coffee
 Or just go for a nice
 Long
 Stroll?

Oh
 Hey there
 I didn't expect
 To see you
 Again
 So soon

What a sweet
 And pleasant
 Surprise

Yes
 I would indeed
 Like to go
 For another
 Long stroll
Only this time
 I won't
 Let go.

typewriterrodeo.com

Custom
Poems

—Sean

post your poem!
#typewriterrodeo
@typewriterrodeo

when you swirl the wine
 the burgundy catching light
like a Hill Country sunrise
 sometimes
you just know
 how the silk will
fill your soul
a perfect blend of tart
an explosion of enough sweetness
to balance the opening world
and in this moment
 the wine
 becomes you
 balancing me
the burgundy becomes the
 unconditional love,
 the love of a pup for her companion,
and also the love for a best friend
 a partner
 a lover
 a wife
 this wine
 is you and me
 standing on a ridge
 and watching our new day
 dawn
 together

KARI ANNE:

FOR SELENA & ROX

for Selena Sierra &
Roxana De Leon

(Austin, TX)

Selena & Roxana: This poem is our most favorite wedding gift of all, not only because of the thoughtfulness behind it, but because it so gracefully and creatively captures a vision of our essence as a couple. We felt that this was a gift from the heart, and we were truly and deeply touched by it.

Our celebration was one of the most important moments as a couple we've had, and we decided to have it in a place that had meaning to us. Our passion for the Texas Hill Country, our affinity for wine, our love for each other, puppies, and family are all rolled into one beautiful piece. The work of art sits in our living room where we see it each and every day and is a reminder of that joyous occasion and the things that are uniquely us.

JODI:

METEOR SHOWERS

for Sara Garcia

(Austin, TX)

Poet's Note: I love when a poem request starts off feeling fairly traditional—a poem for my husband, we've been married almost twenty years!— but then one little element—oh, and we met under a meteor shower!—sends it off on a wild, cosmic journey. . . .

Sara: Ryan and I married twenty years ago (as my grandmother would say, MEK!). I really cannot believe it. It feels like a nano-second except for all we have been through together—end of college, law school, beginning careers, heartbreaking family deaths, and, of course, these incredible boys. My heart is just overflowing with gratitude for all these years we've had, and that we've been able to spend them together.

I asked Jodi for a poem for Ryan about how we met on the night of a meteor shower. We became best friends, got married young, and he's still my best friend some twenty years—and two sweet, funny kids, and many musicals seen—later. And this poem, it really captures all of it, so much more than I expected.

Meteor Showers

If we made a wish

On each of the shooting stars

Streaking across that deep night sky

Could we have imagined ourselves here

a friendship turned love turned family

a household of music and dance

a spiral of joy and the strength of unending support

Meteors burned up in the atmosphere

But the only thing that caught my eye

Was you

"Two acorns fall in love"

there was a crack
 as he fell
and he rolled so far
he didn't know if he would stop
he didn' know where he was
the leaves were gone
the blowing in the breeze over
he was lost
h e was lost
until
the rolling stopped
and he heard a sweet song
it was another crack
and the beat of rolling
toward him
another acorn had lost its way
but had found him
and together they settled
in a little shadowed nook
and they found a new way
 they found newn brighter leaves
they found new breezes
 from the soft happy sighs
of having found
 each other
 however
 improbable

typewriterrodeo.com

Custom Poems

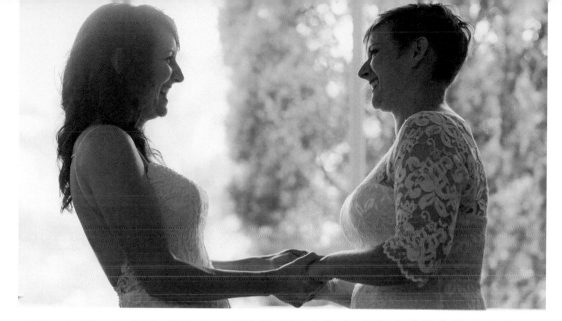

KARI ANNE:

TWO ACORNS FALL IN LOVE

for Rychelle Reiling & Madison Mullins

(Vancouver, Washington)

Rychelle: "Two acorns fall in love" is a story of two people who landed next to each other at an unexpected time and found love. The first gift I ever gave Madison was an acorn I found while at seminary in Austin. It was sitting upright in a crack in front of me, as if to call out its presence. I picked it up, held it, and kept it with me as a reminder to pray for us. Its body held a crack along its side, which reminded me of our own stories and what it means to live openly as queer people and what it meant to be together, in mutuality, at this moment in time. A year and a half later I found another acorn, this one a baby and still a bit green. I picked her up and placed her in my flannel pocket with the thought of giving her to Madison. That evening we went to the Pennybacker 360 Bridge in Austin to watch the sunset; the sky glowed a brilliant red as Madison fell on one knee and proposed . . . she gave me a ring and I, in turn, gave her the baby acorn. Seven months later, we married at Christ Chapel on the seminary campus, fifty feet from where my first prayer began and where our love grew in community (and also where I found the very first acorn).

KARI ANNE:

IT'S VALENTINE'S WEEKEND . . .

for Mary Yznaga & Cas Milner

(Austin, TX)

Mary: Cas and I were at the Harry Ransom Center's "Curiouser and Curiouser" event marking the 150th birthday of Lewis Carroll's *Alice in Wonderland*. Cas is really into old typewriters and was drawn to the Typewriter Rodeo table. It was February 13, and he wanted to get me a poem for Valentine's Day.

The poet Kari Anne asked him what the topic would be. He said, "Well, it's Valentine's weekend . . . we've known each other for forty years, it's been an upward spiral." Actually, we fell for each other almost forty years ago but then married other people, had kids, etc. It's made our current union even sweeter.

She said something like, "got it" and a few minutes later handed us the poem. We moved aside to read it aloud.

By the time we got to the end, we were both completely undone and crying. The depth of its unexpected effect on us had totally caught us off guard. We wiped the tears away laughing and about thirty minutes later, after we had regained our composure, we tried reading it again. It had the same effect the second time!!! We fell apart once again, the tears running down our cheeks. Such a powerful little poem!

The next day I framed it and gave it to Cas for his Valentine's Day present.

"It's Valentine's weekend..."

```
after all these years
you do your thing
and I d o my thing
and our things are sepa rate
 but also entertwined
together longer
than we were apart
 the two of us
ha ging out
movin on up
an aartment
in the sky
forty years it's been
that my heart has been yours
 and I don't miss it
have never missed it
since you tucked it in your pocket
    andcall dit yours
```

— Kai Ave
2/13/14.

for Anne Marie ...love Tom

The only time I can handle

kerning issues
 is when you snuggle just a bit

too close to me

JODI:
KERNING
for Anne Marie Hampshire
& Tom Pearson

(Austin, TX)

Poet's Note: A love poem.
For a couple of typography nerds.

typewriterrodeo.com

Custom Poems

♡jodi

JODI:
CINDY

for Mike Crowley

(Austin, TX)

Poet's Note: We love setting up in the beer garden at Threadgill's when Bob Schneider takes the stage. His show is electric, and his fans are enthusiastic, to say the least. Bob invited us to set up shop near the bar, and we love getting to catch those fans between songs, sneak a poem into their evening.

At one event, Bob's manager Mike came up and requested a poem before the nonstop rush of the show started. "Can I please get a poem for Cindy, about being grateful for a second chance?" He glowed as he told me a bit about how Cindy had come into his life, and how happy she makes him.

When he read the poem, Mike looked at me with wide eyes.

Mike: I was taken aback. The poem was/is perfect. It's framed and hangs in our home. The experience was amazing. I gave Jodi a quick overview and she turned it into a heartfelt poem that embodies the essence of my good fortune in finding Cindy. It was one of life's unexpected and pleasant surprises.

Cindy

There's that twist of light
Right before sunset
When everything's kinda golden
As if we stumbled into a movie
And I catch the slightest glimpse of you
Just doing your thing
And there's this moment, so slight
Where everything sticks
And I worry my feet won't ever lift off the
 ground
And the air tastes like syrup
Three breaths, and I'm back,
But you're still there,
And we're still here
And this is no movie
And there couldn't possibly be anyone luckier
Or anyone I'd rather ride this lucky with.

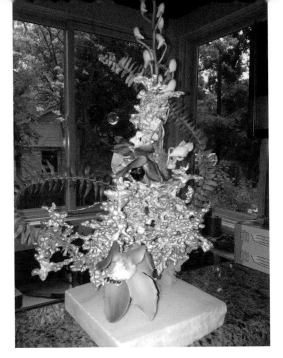

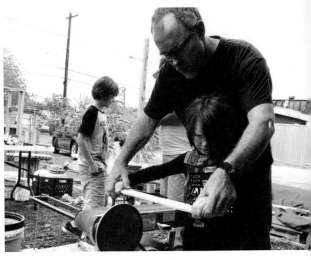

JODI:

MARRIAGE

for Greg Wenderski
& Jennifer Lazar

(Austin, TX)

Poet's Note: Greg and Jennifer had a booth near our booth at Maker Faire Austin, making custom swords. They demonstrated the process of carving a sword, making an impression in a mold, and melting down aluminum or bronze odds and ends and then pouring the molten metal into the mold. Greg does amazing work with molten metal—in addition to leading workshops where kids and adults can craft their own custom swords, he also makes dramatic castings of fire ant nests. He pours the molten aluminum into the mound, and it solidifies into the shape of the tunnels below.

When Greg asked me for a poem about marriage, to gift to his recent bride Jennifer, I knew my way in was through their craft.

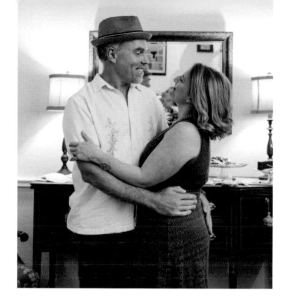

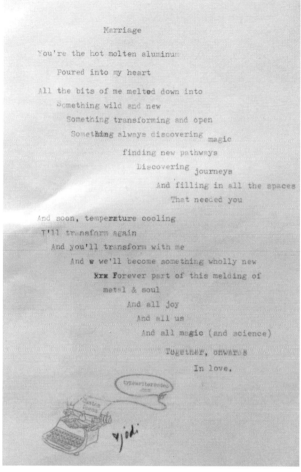

Marriage

You're the hot molten aluminum

Poured into my heart

All the bits of me melted down into

Something wild and new

Something transforming and open

Something always discovering magic

finding new pathways

Discovering journeys

And filling in all the spaces

That needed you

And soon, temperature cooling

I'll transform again

And you'll transform with me

And w we'll become something wholly new

Forever part of this melding of

metal & soul

And all joy

And all us

And all magic (and science)

Together, onwards

In love.

Greg: I've been a big fan of Typewriter Rodeo's spontaneous poems, and the stars had never aligned for me to ask for one before.

Then it was perfect—Jennifer and I had just gotten married, and there we all were together at Maker Faire, so I asked for a poem on the occasion of getting married. I didn't have to think hard about that one at all.

Jodi took it from there, and wrote the wonderful poem about love as molten metal. When I received the poem, I was delighted by the metaphor and thought about metal in a whole different way.

What made it all the more profound—and what Jodi didn't know—was that we used my fire ant casts as table centerpieces at our wedding. I just wasn't aware of what they symbolized until the poem explained it to me.

JAYSON & ERNEST

We've been together quite a while
Fourteen years to ▉ be exact
But there's just one thing we cannot do
One single loving act

All we want's to simply say "I do"
That would make things even ▉▉▉▉ better
But for now we'll wait on you, dear Texas
To get your fucking shit together.

SEAN:

JAYSON & ERNEST

for Jayson Oaks & Ernest Gallardo

(Austin, TX)

Poet's Note: This request came from a museum exhibit opening in February 2015, a few months before the U.S. Supreme Court's decision to legalize gay marriage nationwide. So, at the time of this poem, gay marriage was a state-by-state decision; and of course, in Texas. . . .

Jayson: We were at a gallery opening Valentine's weekend and we saw the Typewriter Rodeo line offering free poems . . . we were intrigued and lined up. While waiting our turn, we tried to think of some ideas of a topic for our poem, but we never settled on one before we reached the front of the line.

When Sean asked us what we'd like our poem to be about I said: "Well, we've been together for fourteen years. We're not married, but maybe someday." Sean thought for a second, said he had an idea, and asked if we were opposed to curse words in our poem. We told him to go for it, and we are glad we did.

Our poem is sweet, irreverent, and most importantly, one of a kind.

"NBD"

```
     the four horsemen lay down their cards
  and look up
   through the jagged maw
   through the steaming hellmouth
Hey, says War. You see that?
      What? asks Pestilence. The Texas thing?
  I saw it, says Famine. Who cares
  Seriously, says Death. Go fish.
         and so they pick up their cards
  resuming their game
  not giving a flying fuck
   who gets married
    to whom
```

KARI ANNE:

NBD

Poet's Note: In February 2015, two women were married in Travis County, Texas. *Obergefell v. Hodges,* the landmark Supreme Court decision that paved the way for legal same-sex marriage in the United States, had not yet been decided. The women, Sarah Goodfriend and Suzanne Bryant, had been in a relationship for thirty-one years and sought permission to marry because of Goodfriend's failing health. A district judge granted their request, and they rushed to get their marriage license before the Texas Supreme Court could reverse the decision.

While many politicians in Texas reacted to the marriage with open hostility, most citizens did not feel personally affronted at all. In fact, the Earth appeared to continue rotating on its axis. Heterosexual marriages did not suddenly burst into flames. So where *was* the apocalypse we were promised? Why hadn't the world ended when two women were united in matrimony? What were those Four Horsemen up to, anyway?

— Kari Anne

33

Octopus On The Moon

See him up there?
All eight legs
Or tentacles
Whatever
He doesn't care about things
Like words
He's got bigger things
To worry about
Like those huge spheres
He's holding
One in each tentacle-arm
All eight planets
That, and the guilt
Over dropping
Pluto

poems of
WHIMSY &
FAVORITE
THINGS

When people have trouble thinking of a topic for their poem, we often say: "I can write about one of your favorite things . . . or least favorite . . . or just whatever first pops into your head."

As a result, we frequently get requests about people's favorites ("the ocean . . . the stars . . . pie"), and just as often about completely random topics ("**an octopus on the moon!**").

We've tried to gather some of those disparate and wide-ranging poems here.

35

JODI:
ALIENS THAT ARE IN LOVE WITH FLOWERS

Poet's Note: This was from an event at the Dallas Museum of Art, where a woman came up and said, "I'd like one about aliens that are in love with flowers." Because who wouldn't want that poem?

Aliens That are in Love with Flowers

For the times of travel, all was lonely
 No friendship. No sharing of the soultalk
 And then we arrived,
 and the orb was loud
 (so loud)

With the sounds and the crashes
 The colorful fleshy ones and the metallic crunchy ones
But we quieted it all down so it was good and wise
 And then we ventured down to meet our new friends

At night we arrived,
 while the nearstar was otherorbited

 And they were shy.
 It was okay. we are all shy at night.

But. When the atmosphere streaked orange
 They awoke, and smiled
 They opened their hearts and we touched stamens
 Connections formed, we bonded, we soultalked
 And soon we tangledroot systems
 We twirled and we curled

 And as our love grew
 This new orb became all enpurpled
 With our newness and our oneness

 Andit was quiet
 And it was joyful
 Andit was good

—jodi

36

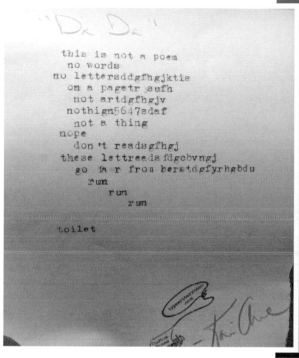

```
"Da Da"
      this is not a poem
       no words
     no lettersddgfhgjktis
      on a pagetr sufh
       not artdgfhgjv
      nothign5647sdaf
       not a thing
      nope
        don't readsgfhgj
     these lettreads fdgcbvngj
        go far from herstdgfyrhgbdu
        run
             run
                 run

      toilet
```

KARI ANNE:

DA DA

for Andy Tucker

(Austin, TX)

Andy: I was at a party to celebrate the 100th anniversary of Tim and Karrie League's house (the owners of the Alamo Drafthouse Cinema chain of movie theaters). They asked partygoers to come in attire related to the time period of the house's construction. My partner at the time thought maybe we could do something related to Dada, a contemporaneous art movement. I used a picture of Hugo Ball that she found as my inspiration, and I did what I could with cardboard, paste, wire, and spray paint the afternoon of the party. Definitely stood out! Made it hard to maneuver, but it was fun having something different, avant-garde to celebrate the occasion.

Oh this goes out
To that one person
The one who says
Poem?
Who the hell needs
A poem?
What could I ever get

From a few words
Strung-typed together
On a sheet of paper
That I couldn't get
Just from being out here
Actually LIVING
In this thing
Called life?

Well
Yup
You are so
Totally
Right
But
"If these flung-together words
Made you stop
Or just pause
For even a moment
And think about how great
LIVING
This life is?
Well
Then maybe
~~something~~ A poem
Isn't so bad
After all.

SEAN:

FOR GIO

(WHO DOESN'T WANT A POEM)

Poet's Note: Oh, how often we've heard it: "A *poem*? Why would I want a poem?" And, oh, how equally often we've heard the response from those same people, once they actually get a poem: "This is so effing cool!"

Not everyone is a fan of poetry. But, we've found that everyone does seem to like poetry when it's about them.

This poem came from the Nantucket Book Festival, when a woman came up to our table and said, "Can you write something for my friend, Gio, who doesn't want a poem?"

typewriterrodeo
.com

Custom Poems

— Sean

38

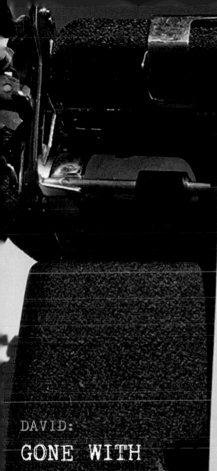

DAVID:

GONE WITH

THE WIND

Poet's Note: And then there are the ones where I know nothing about the topic, but proceed with the poem anyway, in ignorant bliss. Here's one that resulted from a request for a poem about *Gone With the Wind*, which I have neither

Gone With The Wind
(for Shanthini)

i've never read it

but i'm pretty sure it's about
 some lady with red hair

(they called it scarlet back then)

and how she was having problems

because the wind kept blowing her hair away

she was practically bald

but luckily she had this friend,
 Tara

who would go out to the cotton fields

behind her big white house

(maybe it was the actual White House?
 i'm not sure)

and pick those red hairs off the
 cotton plants

where they had been caught up

and the red-headed lady made herself
 a wig

from her own hair

and she showed it to her boyfriend,

but
sadly

he didn't give a damn

THE END

— david

SEAN:

WORSE THINGS HAVE HAPPENED TO BETTER PEOPLE

Poet's Note: How do you write a poem on the spot? A lot of it is simply going with the first thing that pops into your head—and trusting.

At the 2017 Nantucket Book Festival, a woman came up and only said, "I'd like a poem titled, 'Worse Things Have Happened to Better People.'" For whatever reason, that made me think of Pluto. I didn't know why, and so I paused, wondering if there was a better topic; but then I thought nope, Pluto—that's what my gut told me. So I started writing, with no idea where the poem was going. That ride—the journey of discovering the poem as we go—is one of my favorite scary-exciting things. As Neil Gaiman put it: "Where would be the fun in making something you *knew* was going to work?"

←Pluto

40

WORSE THINGS HAVE HAPPENED
TO BETTER PEOPLE

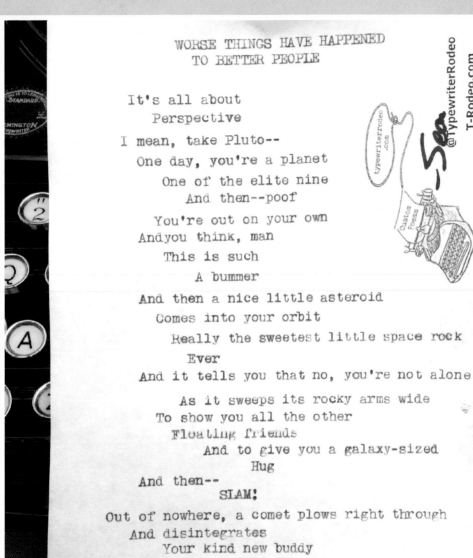

It's all about
Perspective

I mean, take Pluto--
One day, you're a planet
One of the elite nine
And then--poof

You're out on your own
And you think, man
This is such

A bummer

And then a nice little asteroid
Comes into your orbit
Really the sweetest little space rock
Ever
And it tells you that no, you're not alone

As it sweeps its rocky arms wide
To show you all the other
Floating friends
And to give you a galaxy-sized
Hug
And then--
SLAM!
Out of nowhere, a comet plows right through
And disintegrates
Your kind new buddy

And as he sweeps away
In a poof of space dust
You realize that yeah
Things really aren't
So bad.

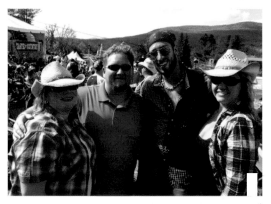

JODI:

LISTENING TO WILLIE

for Christie Grimes

(Sackets Harbor, NY)

Poet's Note: One of our most fun—and most exhausting—gigs was typing poems for nine hours straight at Willie Nelson's Heartbreaker Banquet, which takes place out at his ranch known as Luck, Texas. When Christie requested this poem, it wasn't hard to put myself right back at the ranch and channel that energy into a heart of Texas homesick poem.

Christie: Willie is Texas. After leaving Texas and living in upstate New York for ten years, we long for reminders to take us back: BBQ, Tex-Mex, Shiner, music, and . . . this poem. In bars, festivals, or even a long road trip, Willie's voice softens the day like well-aged whiskey and old friends. Our poem, "Listening to Willie," reminds us of our concerts and travels and all our loved ones still in Texas.

This poem helps us keep a bit of Texas with us.

Listening to Willie

Though there's snow on the ground
 And a chill in the air

 Just a bit of blue skies
 Brings us right back there

Through the heart of Central Texas

 Where the whiskey river shines
 As the steel guitar starts playing
 We've got Willie on our minds

Then we catch each other's eye
 With a toast and a grin
 -Texas calls, it's about time
To be on the road again...

-jodi

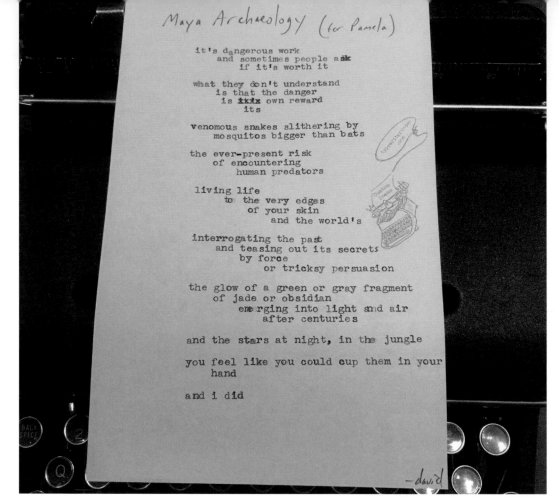

Maya Archaeology (for Pamela)

```
      it's dangerous work
           and sometimes people ask
               if it's worth it

      what they don't understand
           is that the danger
           is its own reward
               its

      venomous snakes slithering by
           mosquitos bigger than bats

      the ever-present risk
           of encountering
               human predators

      living life
           to the very edges
               of your skin
                   and the world's

      interrogating the past
           and teasing out its secrets
               by force
                   or tricksy persuasion

      the glow of a green or gray fragment
           of jade or obsidian
               emerging into light and air
                   after centuries

      and the stars at night, in the jungle

      you feel like you could cup them in your
           hand

      and i did
```

—david

DAVID:
MAYA ARCHAEOLOGY

Poet's Note: For me, the most interesting thing about doing what we do in the Typewriter Rodeo is the variety of people we get to meet and talk with. One of my favorite things to happen in these encounters is for someone to ask for a poem about something I know zero about, but in which they are an expert. That lets me ask them all kinds of questions about their area of expertise, under the guise of gleaning information about the poem. Here's one that resulted from such a mini-interview.

"Working Overtime"

As Dolly Parton would have you know
 nine to five
is hard enough
 but when you add extra
 hours and hours and hours
even Lily Tomlin can't save you
 when she poisons the boss

 because the work keeps coming
 and you kind of want to go crazy
over time

 over time
you suck

 even Dolly Parton thinks so
and she is basically
 a weird angel
 who loves everything

KARI ANNE:
WORKING OVERTIME

Poet's Note: They came up to our table singing Dolly Parton's song "9 to 5." Three women hanging out, laughing, drinking fancy cocktails, but technically still at work. We were typing at a corporate event, and this was the last night of a weeklong convention. The women were obviously having fun, but they were also obviously tired. They discussed poem topics, and eventually each got a poem for their children back home. Before they left the table, though, they asked for one more poem they could share. "Can you write something about working overtime? Something for all of us?"

I could. But Dolly already wrote it for me.

Kari Anne

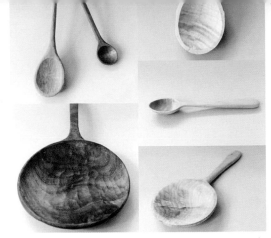

DAVID:

CARVING THE WORLD

for Kat Heitman

(Austin, TX)

Poet's Note: At the Austin Maker Faire in 2016, our poetry table was located near a wood-carving station, run by Kat. About mid-way through the day, she took a break to come over and ask for a poem about teaching a women's-only class on woodworking (with wine).

Kat: I'm pretty sure David was a woodcarver in his past life. The poem, "Carving the World," impeccably captures my experience of the spoon carving process. On a daily basis, I practice meditative carving where my hands do most of the "thinking" and "seeing." The grain of the wood tells me where to make my cuts and marks. I surrender to flow and let my intuition lead the way. Wood chips go flying; a spoon emerges. Wine is poured; creativity is thoroughly enjoyed!

Carving The World
(for Kat)

```
    the spoon
            is there in the block of wood
                all along

    the wine
            is not yet in the belly
                but that's certainly
                    where it belongs

    the curve of the grain
            awaits
                ready to show you
                    the Way

    the edge is the heart
            of the blade
                like the sun
                    is the heart of the day

and when women gather,
        there's power
                to bring shape and form
                    into being

so let it all go
        surrender to flow
                and let your two hands
                    do the seeing
```

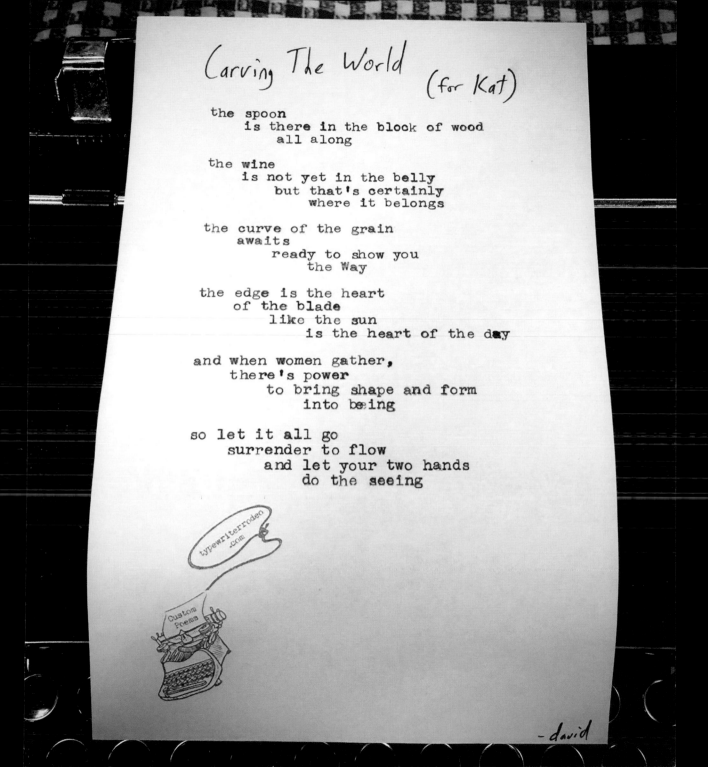

typewriterrodeo.com

Custom Poems

— david

SEAN:
RUBY!

Poet's Note: One of my favorite gigs was when we got to type poems for a midnight book release party of *Harry Potter and the Cursed Child*, in the parking lot of the awesome Austin store, BookPeople. I think everyone there was trying to tap into the magic of Harry Potter once again, and the glory days of the book release parties from the original series.

Nearly everyone dressed up, and we were no exception: at our table, each of us sat decked out in attire from one of the four houses. (I was Hufflepuff. ☻)

We got some amazing poem requests, including perhaps my favorite: "Can I have one about a witch named Ruby? But can you put her in the Harry Potter world?"

RUBY!

It's crazy
 I still can't believe
 JK
 Left her out
I mean seriously
 Greatest freaking witch
 OF ALL TIME?
 Hair even redder
 Than all the Weasleys combined?
 Yeah, it's her
 Sweet, hot
 Ruby
The story untold
 The witch
 Who stole
 Then broke
 Voldemort's heart.
 What?
 You didn't think
 All that anger
 Came just from his parents
 Did you?
 Nope That's the kind of scorn
 That can only come
 From being dumped.

So here's to you, Ruby,
 The original
 Voldemort crusher.

typewriterrodeo
.com

```
      you can pet me
   if you want
   stroke your hand
        over my soft legs
       run your fingers through my
     velvet
          (pant)
       play my strings
         like a guitar
      you can sing to me
        quietly croon
     the blues
          right in my ear
          you can purr
        up against my cheek
        rubbing your cheek
        as if I'm yours
      as if you're a cat
        who can't get enough
    love
           because I guess
          you are a cat
            a cool cat
      you're my cat
        my cool bluesy bluesy cat
      and you know what?
          I'm yours
```

KARI ANNE:

VELVET PANTS, CATS, THE BLUES, & GUITARS

Poet's Note: People will sometimes try to trip us up by giving us a handful of unrelated words and asking for that to be their poem topic. These poems often turn out to be some of the very best poems we write. I don't know what it is . . . the freedom to just take the poem anywhere it wants to go? The challenge of a puzzle? The satisfaction of not being tripped up? Whatever it is, it's gold. And this poem, requested by a tipsy woman in a museum, is a fine example of how sometimes the poems just find themselves along the way.

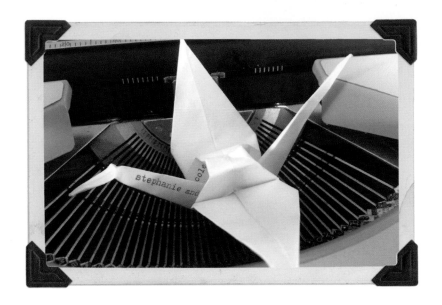

JODI:

PSYCHEDELICS

for Cole & Stephanie Noppenberg's wedding

(Austin, TX)

Poet's Note: One of the magic aspects of the typewriter is that you have fun control of where each individual letter lands. When this wedding guest asked me for a poem on the topic "psychedelics," I knew that I couldn't be constrained by the standard arrangement of text on a page.

They also had an art area, where guests were invited to make them origami cranes. During wedding receptions, we often have to pause for toasts, as the clacking of our typewriters is distracting, but at this reception I spent that break folding origami cranes.

Psychedelics

i cannot believe

any version of reality

that cannot account

for the beauty

i am feeling

as i see

deep inside

your sweet

delicious

goodness

and each letter holds a rainbow

where words spin sideways

variation in the algorithm

this is the kind of poem

that needs some

jodi

Stephanie & Cole
May 2016

DAVID:

AN OTTER,
A RED PANDA,
AND A SLOTH
WALKED INTO
A BAR . . .

Poet's Note: Sometimes people like to try to stump us—it cannot be done! As Kari Anne noted, one way they try, every so often, is to give us a collection of disparate items and say, "Make a poem out of THAT—if you can!!!" Little do they realize that this is nothing but a gift of pure inspiration, the unexpected juxtaposition providing a fertile ground for all kinds of metaphors and hidden connections. We love the stumpers! Here is one I particularly enjoyed.

An otter, a red panda, and a sloth walked into a bar... (for Danny)

sure, it was the middle of the day

sure, they all ordered double bourbons
 with a water back

they were thirsty

it's hot work
 being so adorable

being a mammal
 is no picnic

so sure, they ordered another round

they may have even told the bartender
 (a very cute platypus
 in on a student visa
 from new zealand)

to leave the bottle

what else are you supposed to do
 on a long, hot afternoon
 in the city

evolution didn't prepare us
 for this hustle-bustle
 workaday world

at least in the bar

it's cool and dark

and the whiskey
 kills the pain

and they raised a glass to Darwin...

Two Sleeping Cats, A Pocketwatch, and a Kiss

It was nearly time

(not quite time, for if it was quite
time, you'd know,
with the ticking of the pocketwatch
and the chiming of the hour and all)

But no,
it was just nearly time
And when it is not yet time, the cats will just
sleep.
And that is because the cats who sleep
will always sleep
until it is time
(of course)

But then (did you see this coming? for I did not)

Then it was time.

And so the cats stretched and woke
And they purred, and they prepared.

And then it began: The Kiss.

And then it ended (for it was no longer
time)

And then they cats returned to sleep

Until the pocketwatch announced that
it was time once again

—jodi

JODI:

TWO SLEEPING CATS, A POCKETWATCH, A KISS

Poet's Note: This poem was just so much fun to write—the mystery of how to combine these three disparate topics, the adrenaline burst as a narrative emerged, and the gasp from the recipient, who thought she was stumping me, but rather gifted me with a moment of inspiration.

SEAN:

TYPEWRITER SHOP

for Tom Furrier

Owner, Cambridge
Typewriter Co.

(Arlington, MA)

Tom: I was at the Antiquarian Book Fair in Boston two years ago. I was all excited to meet Typewriter Rodeo, because I'd been following them on Instagram. I made sure I was the very first person in line, and I got the very first poem of the day.

I asked for "typewriter shop" because I own one, and I wanted something I could hang up on the wall for people to read.

As soon as I got the poem, I read it and was like, WOW. And I was there with my wife and daughter, and they were like, WOW, too. I love it. It's framed on the wall behind my desk.

I was initially a forestry major in college, wasn't really doing what I wanted, was looking to get into something different, but I didn't know what. The original shop owner was my next-door neighbor; his son and I were friends. My friend asked me if I'd like to come learn how to fix typewriters

and work for his dad. I hadn't really thought about it, but said, "Yeah, I'll try it." His dad said, "Come in for a week and we'll see how you do." At the end of the very first day, a voice in my head said, "This is it." And I knew this was what I was going to be doing for the rest of my life. That was 1980. I've been here ever since.

It wasn't easy, because personal computers came in the mid-80s. My boss retired in 1990, and I bought the store from him, did whatever I could to get by. Then right around 2001, the whole vintage thing started up. And it just kept snowballing every year after that, a little more and more.

People come in and everyone's got a personal story about their typewriter. All I do is sit back and listen. It's just really cool. After thirty-seven years, it's still my dream job.

Tom, working on Sean's 1920s
"Mountain Ash Scarlet" Corona

TYPEWRITER SHOP

Step right in
 Let that door slowly close behind you
 And welcome
 To a bit
 Of the past
Where you can see the ~~magic~~ machines
 That wrote all the books
 Long long before computers
 Were even a microchip dream
The clacking keys
 That sped out war correspondence
 Love letters
 And the earliest
 Of term papers
It's all here
 Inside this little shop
 Brimming with metal and keys and ribbons
 All of it ~~was~~ here
 Just waiting
 And if you close your eyes
 And breathe deep
 You can almost feel it
 Here, in this place
 History
 Comes alive.

the good thing about following rules
 is that you can break them
i mean come on

like this is an actual poem?
 HA
but how could it be written?
 if there was no Bukowski
 if there was no sonnet-inventor?
we owe our lives to rules
 but we owe our pleasures to breaking them

is this poetry?
 it is now, motherfuckers

because i said so
 and the best part of breaking rules

 is making new ones

a cycle of creating and breaking
 and breaking and creating
everything is anything
 when you color outside the lines
 when you take a chance
on that first step over the boundary

 that only you know
 is there

KARI ANNE:

HE NEVER BREAKS
ANY RULES

Poet's Note: People will sometimes approach us and ask what kinds of poetry we write. Often, these are smart-alecky people who are testing the waters before asking for something like a sestina or a villanelle. They will wonder aloud at how we're able to memorize the rules for any and all forms of poetry (spoiler: we haven't). That's usually when a discussion arises about how poetry can be anything, and how once you know the rules for something you can more easily (and possibly more meaningfully) break those rules.

 One man I spoke to wasn't a fan of the fact that my poetry was going to be free-form. His wife shrugged. "He never breaks any rules," she said, and a poem was born.

— Kari Anne

56

Elephants

I have wandered across this terrain
And seen all there is to see
Hosed down my best friends
The antelope all love me

I make the hottest days a blast
A roaming water park
Even the hyenas come running
And we play til it all grows dark

I can recall the greatest stories
And the most enchanting rhymes
I try to tell the humanfolk
But they rarely have the time

So I reach out to the dolphins
Via the river to-sea network
And we laught at the greatest mysteries
And the deep sea creatures that lurk

For I'm a transpacific elephant
And the earth is my land to roam
I'll journey miles and miles
No acre is not my home

typewriterrodeo.com

Custom Poems

- jodi

JODI:

ELEPHANTS

Poet's Note: One of
the ways I challenge myself
when writing poems is to
play with perspective and
point of view. I love to try
to see the world through
unusual or unexpected
eyes, like perhaps from the
poem topic's viewpoint.

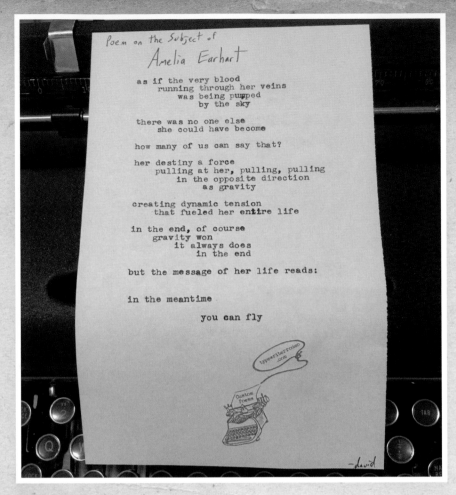

Poem on the Subject of
Amelia Earhart

```
as if the very blood
      running through her veins
            was being pumped
                  by the sky

there was no one else
      she could have become

how many of us can say that?

her destiny a force
      pulling at her, pulling, pulling
            in the opposite direction
                  as gravity

creating dynamic tension
      that fueled her entire life

in the end, of course
      gravity won
            it always does
                  in the end

but the message of her life reads:

in the meantime

            you can fly
```

—david

DAVID:
AMELIA EARHART

Poet's Note: I've always admired the trailblazing pilot Amelia Earhart, so much so that I named my daughter after her (see "My Dead Doll" in *Poems for Kids*). So, I was delighted to receive a request to write a poem about her, and this is what came out of the typewriter when I did. I think that most of the time, the more personal a connection I have with a topic, the better the poems come out (though not always!), and I like this one a lot.

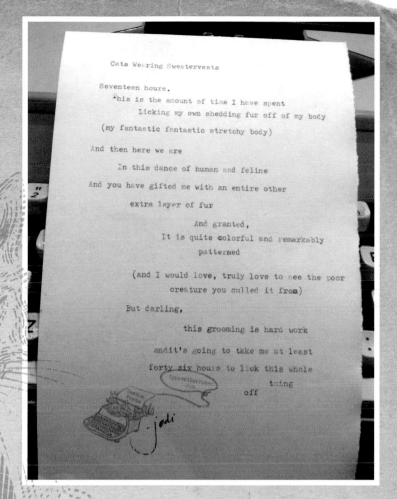

Cats Wearing Sweatervests

Seventeen hours.
 This is the amount of time I have spent
 Licking my own shedding fur off of my body

(my fantastic fantastic stretchy body)

And then here we are

 In this dance of human and feline

And you have gifted me with an entire other

 extra layer of fur

 And granted,
 It is quite colorful and remarkably
 patterned

 (and I would love, truly love to see the poor
 creature you culled it from)

 But darling,

 this grooming is hard work

 andit's going to take me at least

 forty six hours to lick this whole
 thing
 off

— jodi

JODI:
CATS WEARING SWEATER-VESTS

Poet's Note: We get tons of poem requests for cats, so I'm always delighted when someone adds a new wrinkle to that topic. . . .

SEAN:
FLATLINE

Poet's Note: The more people learn about Typewriter Rodeo, the more often we hear from fans, poem recipients, and strangers on social media. When something interesting is going on that has the Internet abuzz, we'll often get poem requests online. This was one of those requests, in response to a short-lived snake hysteria in Austin in the summer of 2015.

Specifically, a man was found dead in his car in a Lowe's parking lot, bitten by a cobra—which he'd apparently kept as a pet. But the cobra

was nowhere to be found. For several days, Austinites joked about where the cobra would turn up and nervously checked around for strange slitherings. Finally, the snake was located—it had been run over on a stretch of Interstate 35, the highway that Austinites often try to avoid because it's seemingly always congested. (This is a photo of the cobra after it was found by the Austin Police Department.)

We got several Facebook requests to write a poem about the snake, and dutifully obliged.

You touched our hearts

FLATLINE

Fifteen minutes
Is all it takes

For that rocket of fame
Even for snakes

You touched our hearts
And scared us too

And made us look twice
When we went number two

Oh #AustinCobra
No longer alive!
You broke the big rule:
Never take 35.

—Sean

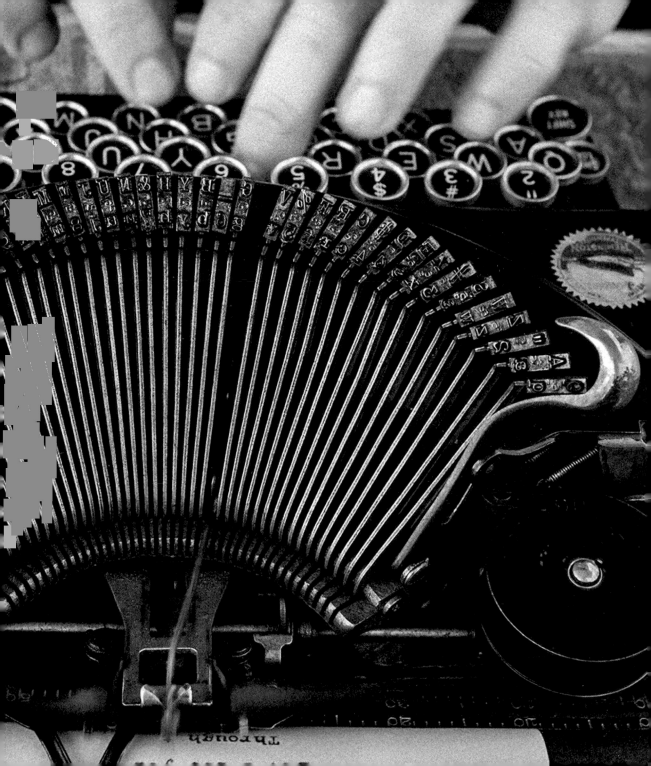

poems of
VULNERABIL-
ITY

"Vulnerability is the core, the heart, the center, of meaningful human experiences."
—Brene Brown, Daring Greatly

One of the most amazing, honoring, and humbling things is when people come up to our table and share intimately personal aspects of their lives.

"I'm having a really tough time . . ."

"I just went through a breakup . . ."

"I lost a parent . . ."

Maybe it's because we're strangers, and we'll never see each other again. Maybe they sense something special about what we're doing—this momentary collaboration, where the typewriter forces us to be completely open and transparent with them, too. They can literally see each letter we type the moment it comes out; with a typewriter, there's nowhere to hide.

Whatever it is, when these moments of mutual vulnerability happen, it's often a rush of emotion on both sides of the table, a beautiful mix of sadness and joy.

Then we try to put just a fraction of that onto paper.

KARI ANNE:
SEPARATING
for Mike DeGraff

(Austin, TX)

Mike: In April 2014, my wife told me she was moving out. We had already been trying an in-home separation, which is exactly what it sounds like and also as ineffective as you're thinking. I moved to the guest room and we tried to negotiate our lives as if we were not married, but living in the same house like roommates and taking shifts parenting our child.

I was five when my father left; my son is now four. When I think about my five-year-old self, I see Oliver's face instead of mine and am overcome with a deep sadness that wells up from the pit of my stomach and lodges itself in the back of my throat. I am so scared that I won't be the father I want to be and that Oliver deserves, that I won't know how because no one has ever shown me.

One month after my wife moved out, I came across the Typewriter Rodeo. I walked up and said: "I'm going through a separation. I'd like a poem about that." What I got was the best thing anyone has yet to say to me in the wake of all of this.

Poet's Note: Some time later, Mike found us on social media and sent us a photo—he'd had the first line of his poem tattooed on his arm.

"Separating"

 coming together
 and breaking apart
 this happens to a lot of things
 in life
 though when it happens to yourself
it can be a bit of a shock
 until you realize
 that breaking apart
 busting something wide open
 is like creating a rip in the sky
 and what you thought was finite
 what you thought had a ceiling
 is suddenly open
 and stretching wide
 and moving forward
 into a new divide

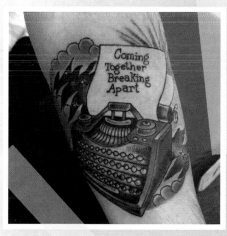

I HOPE TO BE LOVED

Some people wish
 For grand houses
 Perhaps the latest
 Fastest car

 Others may dream
 Of the supposed life-fulfilling wonders
 That come with the gleam
 Of fame

 But oh
 Way atop all those
 Above the mountain of wishes

 Up here in the cloud
 Of hope

 Me
 I just wish
 For a calm
 Steady
 And serene hand
 To hold
 In mine.

Sharon & Sean

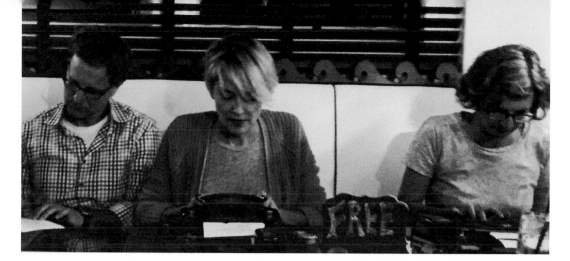

SEAN:

I HOPE TO BE LOVED

for Sharon Stone

(Hollywood, CA)

Poet's Note: At the 2016 Nantucket Book Festival, Sharon Stone came up to our table. Yup, that Sharon Stone.

She asked for a poem about her sons from Kari Anne. There was no one else at our table, and Sharon was just standing there, so while Kari Anne typed I said, "I can write you a poem, too, on whatever topic you want."

Sharon paused a moment, then simply said, "I hope to be loved."

I nodded and started typing.

With every request, it's a collaboration—we take a topic from someone else, add a bit of ourselves, and make a poem. But as I was typing this particular poem, I remember thinking how all of us have the same wants and needs—from celebrity to peon poet—and how grateful and honored I was that Sharon would share that bit of herself with me, a stranger. So I tried to tap into my own feelings as I was writing this poem, I think even more so than normal. And by the end, I found myself half writing the poem to her, and half to me.

After both Kari Anne and I were done, Sharon read her poems silently, then came around the table and gave us each a hug. "You made me cry," she said. "You both did, with these poems."

Later, Sharon (a huge poetry fan) joined our table, got behind a typewriter, and became an honorary Rodeo member—typing poems right alongside us.

JODI:
CAT
for Vanessa McCann
(Austin, TX)

Poet's Note: Once a month, Austin's Children's Museum, The Thinkery, hosts a 21+ night, where adults can enjoy all the exhibits. This night was one of our earliest gigs, and we were slammed—each one of us had a line twenty people deep, and we typed until our fingertips were numb. It's hard at such packed events, because there's a moment of overlap

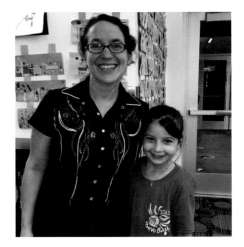

between two poem recipients—I want to watch the first person read and react to their poem, while I also want to welcome and connect with my next poem recipient.

When Vanessa walked up to me, she spoke quietly—unusual in this jam-packed and laughter-filled night. I'll never forget her request: "I'd like a poem for my six-year-old daughter, Cat. She loves her Daddy very much . . . but her Daddy is in heaven."

These are the most powerful, most quietly surprising moments—where someone lets you in on their intimate pain, where a night out with friends becomes a space for grieving and connecting.

I wrote, trying hard not to overthink, to just type, and to let the words and the emotion flow. I handed the poem up to Vanessa, and she walked off with her friends. As I started in on the next poem, still feeling a heart-tug to connect with Vanessa, I looked over and saw her friends surrounding her, a tight hug. Moments later they came back, tears in their eyes, to thank me. And I was able to thank her too, for letting me in and letting me offer up this poem to her daughter.

This poem sat with me, but was one of the many thousand experiences we've had, where a poem is written and then

Cat

```
Surrounded by love
From down here, from above
Every whooshing of the wind
Every crashing of a wave
Every swirl of a skirt
Every tasty chocolate cake
Inside if you listen
A sweet message you'll hear
Love from a daddy who wishes he were near
So journey through this world
Explore, adventure, have fun!
And listen for each message
Love from a special dear one. . . .
```

flies off into the ether—home with the recipient but gone from our world.

That is, until we were typing poems for the University of Texas Elementary School's Bevo Bash in May 2015. Another fun, lighthearted day, typing lots of dragon and cupcake poems. A mom and daughter appear, and the mom says: "You wrote a poem for my daughter at The Thinkery last year, and it's still hanging on her wall." And oh, I knew. I'd accepted that our moment together was just a flash in a lifetime, but here we were, together, and even better—here was Catarina.

We hugged, we took our picture together, and since then have kept our connection going through social media.

DAVID:

HOW TO LIVE LIFE WITHOUT BEING AN ASSHOLE

for Ruth Pennebaker

(Austin, TX)

Ruth: We all have recurring dilemmas in our lives. One of mine reared its unattractive head recently.

I was having a conflict with a former business associate because I'd ended the association. It got personal, and it got very ugly. I pulled back from the increasingly bitter exchange and tried to think about it calmly.

Naturally, I wanted to see myself as a blameless victim. But it didn't quite work. I don't care whether you divvy up the percentages showing me to bear 20 percent of the blame or more or less; the fact is, I bore some responsibility. At some points, I hadn't acted well and I felt uncomfortable recalling my behavior. Sic transit total victimhood.

Fortunately, it was a Saturday and we were in the thick of one of my favorite events, the Texas Book Festival. Moving through the free-for-all of tents and exhibits, I bumped into the Typewriter Rodeo. This is a group of young writers with manual typewriters, quick fingers, and even quicker wits who'll write you a new, fresh poem for nothing. Or for a tip, if you'd like.

You step up, you tell one of them who the poem is for, and you go on to describe whatever underlies your request—a mood, an occasion, a relationship. It's kind of unnerving because it can be so damned revealing: Who are you and why are you here? You're telling that to a total stranger who has fingers poised, ready to write the verses of your life. It's part art, part therapy.

"I think I've acted like an asshole recently," I said to David Fruchter, who was commandeering one of the

70

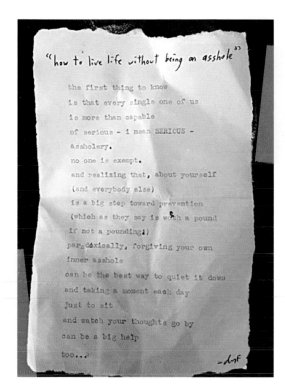

HOW TO LIVE LIFE WITHOUT BEING AN ASSHOLE

the first thing to know

is that every single one of us

is more than capable

of serious — I mean SERIOUS —

assholery.

no one is exempt.

and realizing that, about yourself

(and everybody else)

is a big step toward prevention

(which as they say is worth a pound

if not a pounding!)

paradoxically, forgiving your own

inner asshole

can be the best way to quiet it down

and taking a moment each day

just to sit

and watch your thoughts go by

can be a big help

too . . .

keyboards. "And you know," I told him, "I don't want to be an asshole."

He nodded—like this wasn't a strange request from a woman he'd never met before. Then he bent over and started typing. Minutes later, he gave me a poem on a gold rectangle of paper.

I took my poem, read it, left a tip, and walked away. I knew the Typewriter Rodeo served other purposes for other people—like romance, and sentiment, and whimsy. For me, it helped calm me down a little and made me think about how I could be a better person.

Self-reflection, a little judgment, humor, ideas on how to live better. Good grief, what a deal. I'm thinking Typewriter Rodeo should be on every corner of the universe.

BAILEY

You
This beacon of bright
Fiercely loyal
Love

You
This straight-shooter
Blazing across lives
As quick to defend the defenseless
As to crack a sly, side-splitting joke
This force of nature
Strong-willed, independent

And the rarest grace
Of toughness mixed with tender
You
Our Bailey

And it's amazing to think
Not of what we lost
But of what we were given
What we were blessed with
The gift, even for far too short a time,
The sparkling, wondrous gift
Of your star, in our sky

You
Our Bailey
Who lit up the world
And whose light
Will always
Always
Shine.

SEAN:

BAILEY

for Jeff & Ericka Sharp

(Seattle, WA)

Poet's Note: Nearly all our poems are written for strangers. But sometimes, we'll get a request from a friend. In this case, it was a Facebook friend I hadn't really seen since high school. Out of the blue, I got a message saying she had been following our Typewriter Rodeo page, and asking if I could write a poem about her daughter, who had just been killed. I was humbled, and floored, and just honored that she would even think of allowing me to write that poem.

Ericka: After our twenty-three-year-old daughter, Bailey, was killed at the hands of her boyfriend, our days were spent in endless waves of stunned silence, overwhelming sadness . . . disbelief, and reflection that we tried desperately to somehow make sense of.

It was during the aimless wandering through those first few days that I saw some pictures from an event Typewriter Rodeo had participated in come through my news feed. I had always enjoyed the poems that had been posted, as well as admired the ability for such creativity to be produced in such a short amount of time. It struck me in the moment that having a poem about Bailey would be something that could forever embrace the idea of her and her time here on Earth in such a unique and timeless way.

When I messaged our childhood friend explaining what had happened and asked if he would please consider writing a poem for us about Bailey, he could not have been more kind and sympathetic. After offering his heartfelt condolences, he simply asked for a brief description of her. From that, it was the way in which he strung together the pieces of her into a sort of living memorial truly embracing her essence that left me in tears. It was, and is . . . beautiful.

This amazing gift resides beside her urn where it has been read countless times and will forever be woven into our remembrance of Bailey. "Thank you" will never seem a sufficient show of our appreciation.

KARI ANNE:

HATING YOUR EXISTENCE

Poet's Note: One of the questions we get asked a lot is whether or not we ever refuse a topic. The answer is: almost never. Sometimes we'll do a double-take and ask for clarification. Sometimes we'll take the topic and give it a twist. We'll never write a poem we would be ashamed to share publicly.

At one event, a young woman had waited in line for quite a long time. When it was finally her turn, she gave me a steely look. A daring look. I stared back. After a moment, she broke the stare, turning her gaze to the table. When she looked back up, her defiance was gone. Sad eyes, arms crossed. "Can you write about hating your existence?" she asked.

Now, sometimes people ask for topics like this and there's a glint of sarcasm or exasperation. There's hyperbole and eye-rolling. With this girl I saw none of that. I saw a backwards ball cap, a pierced lip, and shades of my own youth.

"Yes, I can," I answered. But when I was finished with the poem, I didn't feel like I could let her go just yet. So, for the first time, I added a *Poet's Note* to the end of the poem.

"*Hating your existence.*"

```
  everything is terrible
for real
  it's the worst
 there is no reason for anything
   there is no reason for me
if you think of the universe
   and how big it is
every person is j st like dust
  even smaller than dust
   just specks of nothing
worthless in the long run
nothingness compared to
   supernovas
 and the formation of galaxies
    and it's kind of freeing
 I guess
to hate existing
  when existing is barely anything
   at all

(Poet's note:
   even though we're all small
  it is statistically
  impressive
that we exist at all
   so there has to be something
 cool about that
   right?)
```

DAVID:

I HEAR HIS VOICE

for Peggy Blevins

(Austin, TX)

Margaret Blevins: My mom, Peggy, died this past winter. Going through her things, I found a framed poem that my mother-in-law had commissioned for her as a present the Christmas after my dad died. It was about my dad and how he was still so much a presence in the house they had lived in for more than forty years.

She loved that poem. It made her weep and smile at the same time. I remember she asked me to make copies and send them to my dad's sisters. Mama kept that poem near her until she died.

Now I have that poem and it makes me weep and smile, too.

Thank you for helping keep both my parents and the love they shared alive. . . .

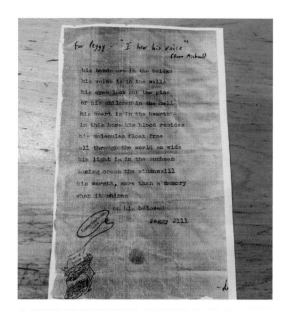

his hands are in the bricks

his voice is in the walls

his eyes look out the pics

of his children in the hall

his heart is in the hearth

in this home his blood resides

his molecules float free

all through the world so wide

his light is in the sunbeam

coming across the windowsill

his warmth, more than a memory

when it shines

on his beloved

Peggy Jill

SEAN:

MY BROKEN HEART

for Katha Sokoll

(Austin, TX)

Poet's Note: When I get a poem topic, sometimes I'll ask for more information. But other times, especially when a stranger is sharing something vulnerable, I just take that gift and start typing. That's what happened when Katha came up and simply gave me three words: "My broken heart." I didn't ask her anything more, and it would have felt like breaking the connection if I had. When I was done, I handed her the poem and said what I often do for topics that are so personal: "Thank you for letting me write this."

Katha: My beau of eighteen months broke up with me relatively out of the blue, on a Tuesday. We had traveled and cooked together, shared our friends and children and families with one another, and I had really stretched myself to learn about how different people share and express love outside of my own verbose style. I had a hope for our future and assumed we had a mutual respect for discussing things.

The breakup was quick. He had decided. I didn't ask too many questions. There is no reason to argue about someone no longer wanting me in his life. It takes two people to be in a relationship, and one person to end it. What was left is the pain, the gap in my life and gut and heart, the tossing and turning all night long, the dread of weekends and the time when my kids are with their dad and I struggle to occupy myself. It still stings like hell.

Three days later my sister and I were walking down South Congress when I saw a couple of folks from the Typewriter Rodeo set up near Guero's Taco Bar. I

pondered requesting a poem then, but opted for margaritas instead.

About a week later, I took my sons to the Austin Maker's Faire and saw the Typewriter Rodeo gurus again. It was kismet and for god's sake, I needed a lift from the terrible, depressing haikus I had been composing (see below):

Did he just play me?
Heartache doesn't change
Disregarded, discarded

Heavy hearted and empty
Like we were nothing
No matter my age

Needless to say, Sean's interpretation of "My Broken Heart" offered a lot more promise and optimism than I've been able to conjure. I cried. I took the poem home and left it on the kitchen counter to read and re-read. I took a picture of it on my phone to read and re-read. And then I placed it in my box of love notes alongside the memories of love and peace and hope and beauty that I've collected throughout my life. Thankfully time and perspective are slowly healing. I know that this romance will eventually fade into a memory . . . for better or worse. And hopefully I can muster the vulnerability to open my heart again one day. Thank you, Sean!

MY BROKEN HEART

It's weird
 I can put my hand

Right there on my chest
 And I can feel it

Feel that thrum and beat
 Feel it going and pumping
 Like ████ it's working
 Like everything in there

 Is just A
 OK

But oh
 If you could take an X-Ray
 Of feelings?

 An MRI
 Of emotion?
Yeah if you could do that
 You'd see the truth--
 A wrecking ball
 Slamming again and again

 Into this cracked and broken
 Wasteland

 But also
 If you look
 Watch
 And wait
 You'd see that wrecking ball
 Each time
 Getting a tiny
 Bit
 Slower
 So that maybe
 Someday
 This unseen pain
 Will finally
 Fade
 Away.

77

JODI:

TERMINUS, FOR ANNIE

for Nicole Spradling & Cara Canary

(Austin, TX)

Poet's Note: Nicole asked me to write a poem based on a play her daughter, Cara, was in, where she portrayed a character named "Annie." (The play, titled *Terminus*, was written by Gabriel Jason Dean and directed by Rudy Ramirez, and produced by The VORTEX, an Austin theater.) When I asked Nicole for a bit more background, I got much more than I ever could have expected. And a story I'll never forget.

Nicole: "Annie" was once a neglected little girl who lived many, many years ago. She was taken from her mother and placed in an asylum where she spent the rest of her years. In 2015, her character was included as a small supporting role in a play written by a New York City playwright that debuted in Austin. My daughter,

actress Cara Canary, was asked to play the role and spoke aloud to ask the spirit of the long-deceased Annie for her blessing to play her. Cara asked Annie to channel her and let her know if she was happy with the way she was portrayed.

Rehearsals often ran late into the night, and once I was awakened by Cara for her usual goodnight hug and kiss. Sensing sadness, I asked: "Are you okay, Cara?" "This isn't Cara," came the reply, "it's Annie." The time was midnight, and Cara was still at rehearsal with her dad. When Cara's father returned, he watched the shadow of a girl walk into a closet.

On the morning following the final performance, Cara was awakened in her bed to the sound of clapping in her ear. Groggy and sleep-deprived, Cara tried to ignore the sound, but it persisted and

```
                    Terminus, for Annie
      There's gratitude in me

            That I just dont quite know how to express

      That I am
            that I can be
                  that I continue to be
                        That you see me
                              That you honor me

      And though it appears that I have become

      A shadow of my former self

      Slipping in and out of the edges

      Bouncing against sunbeams

                  and slinking into corners

      i will take your welcome

            I will send my gratitude

            I will release myself

                  Spin myself a new form

                        Up on a stage

                        My story, told anew
```

traveled across her bedroom increasing in volume until it suddenly stopped. A few nights later, Cara's dog Ethel woke up the family around one in the morning with a slow, deep growl. Ethel is an overly protective dog and was told to be quiet, so she put her head down but her eyes remained fixated at something in the bedroom. Throughout the night, she would periodically raise and tilt her head looking at the same empty spot in the room, then again alert the family with a warning growl. I finally spoke aloud in the room asking Annie to please leave the house because her presence was too scary. After that moment, the dog was fine and there were no further occurrences in the house.

For a brief moment in time, little Annie was acknowledged and was able to see a small portion of her story shown. Her solemn spirit finally found a loving home where she had been requested, but tragically she was again made to leave, and she did so respectfully and honorably. There is much depth in Annie, and one day the world should be able to see more of her story.

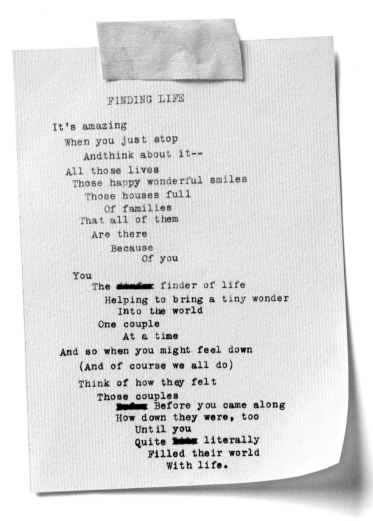

```
              FINDING LIFE

     It's amazing
        When you just stop
           Andthink about it--
        All those lives
           Those happy wonderful smiles
              Those houses full
                    Of families
              That all of them
                 Are there
                    Because
                       Of you

           You
              The ▓▓▓▓▓ finder of life
                 Helping to bring a tiny wonder
                    Into the world
                 One couple
                    At a time
     And so when you might feel down
        (And of course we all do)
           Think of how they felt
              Those couples
                 ▓▓▓▓ Before you came along
              How down they were, too
                    Until you
                    Quite ▓▓▓▓ literally
                       Filled their world
                          With life.
```

SEAN:

FINDING LIFE

Poet's Note: Sometimes it will take a question or two to get the most important information for a poem.

At the Washington, D.C., Antiquarian Book Fair, a man came up and said: "Can you write a poem for my wife? She's going through a really tough time. She's just amazing, but she doesn't know it. And she's had her own business, that she started almost twenty years ago."

"Of course," I said. "What's her business?"

"She finds surrogate moms, for couples that can't have babies."

"Courage"

```
    it can be the smallest little moment
  that makes the biggest difference
        the time when you actually hear
    your gut
    instead of ignoring it
  it can be a second out of millions
  when something finally clicks
  and you figure out the puzzle piece
      the one that actually fits
  anything can be courageous
    if it comes at the right time
      anything can break your heart open
      and finally
                finally
                      make it shine
```

KARI ANNE:

COURAGE

Poet's Note: A woman approached our table with some trepidation. "I don't really know what to say," she began. "I'm just . . . I'm having a hard time right now."

One of the mysteries of Typewriter Rodeo is why strangers trust us with some of their most personal feelings and confessions. Is it because we're strangers and they know we'll likely never see each other again? Is it because they feel the intrinsic pull of poetry and all the historical weight behind it? Are we confessors? Anonymous co-conspirators? Fortune-tellers? All of the above? These are questions we can't really answer, but what we can do is listen. And interpret. And offer non-judgmental words that hopefully hit the right mix of compassion, encouragement, and commiseration.

"Oh my gosh," the woman said after I handed her the poem. She kept repeating that. "Oh my gosh. Oh my gosh. Oh my gosh." Tears spilled down her cheeks as we met over the typewriter for a hug between strangers.

Everyone needs courage. And sometimes the most courageous thing we can do is to trust a stranger with a moment of vulnerability.

SEAN:

THE FOUR Bs | DARK HUMOR

Poet's Note: One of the crazy things about what we do is the variety of poem requests—how different they can be, literally from one to the next.

At Willie Nelson's Heartbreaker Banquet, an all-day concert at Willie's ranch that was part of the 2015 South by Southwest music festival, we typed poems for a non-stop crowd, for nine hours straight. It's still one of our favorite gigs.

Late into the night, near the end of that poem marathon, two young women came up to the table. The first grinned at me and said: "Can you write me something about bakeries, babes, bacon, and boners?" I wrote her a poem titled "The Four Bs," and she and her friend read it and laughed.

Then her friend leaned in and asked for her poem: "Mine is a bit darker. My dad died ten years ago, my mom ten weeks ago. I tell myself there's some sort of dark humor in it, because I have to, it's the only way I can deal. Can you write something about that?"

I took a breath, to mentally shift gears from the previous poem, and then wrote. I snapped a photo of each poem, but never got to see the second poem being read, never saw either of them again, as they moved past the lines of people waiting for poems, and disappeared into the dark.

THE FOUR Bs

Some people think
The greatest B ever
 Is the boner
And I won't lie
 Boners are pretty fucking sweet
 Until they're gone.

Others think babes
 Are the best B word
And I won't lie
 Babes are fucking awesome
 Until they're gone.

And so many
 Many people
 Bow down to the B word
 Of bacon.
& And ohmyholyfuckingorgasminmymouth
 I love me some bacon
 Until it's gone.

But the best B word?
 For me, it's bakery.
Donuts and pies and fresh fresh bread
 I can eat all I want
 But the bakery
 Never goes away.

PUNKS & POETRY

—Sean

STANCE

82

DARK HUMOR

Let me tell you a joke
Ten years ago? ~~My~~ My dad died.
Ten weeks ago? So did my mom.

 Oh, you're not laughing?
 Don't you see the humor,
 The huge cosmic fucking hilarity
 Of it all?

 I do.
Because if you don't?
 If you're the sort of person
 Who lets the death of their parents

 Haunt their shoulders
 Drag them down with every step
 Then eventually you'll

 Just
 Stop
 Moving.

And that, oh that
 Isn't life.
 Because while my parents may be gone
 I am not.
 AndI can grieve, oh fuck yes I grieve

 But I can also laugh

 And be grateful
 For the memories I'll always have
 And for the future
 That is yet
 To be.

—Sean

83

OPEN LETTER, TO MR. GREGORY ---:

Dear sir
 Or should I say "G"?
 No--
 That casualness
 Evaporated
 Just like you did
 Two years ago
 In an inexplicable "poof"

Only with you
 It was the opposite of magic
 Though still
 When you did your vanishing act
 You took my heart
 Along for the ride
(First skewering it, of course,
 With long swords that were, alas,
 No trick)

And now
 Here you are again
 In another sudden, inexplicable

 Poof
With words like a show
 A mirage of substance
Which
 I guess
 Is kind of like
 You
 You, Mr.---
 Mr. Greg - Ory
You, who reappears with a flourish
 Perhaps expecting me
 To leap right back to your side

But oh
 Mr, --- --
 My days
 Of being a magician's assistant
 Are so
 Fucking
 Over.

SEAN:

OPEN LETTER, TO MR. GREGORY - - -

for Bayne Gibby

(Los Angeles, CA)

Bayne: When I finally worked up the nerve to profess my love for my best guy friend, Greg - - - , it didn't go so well.

He told me:

1. He was flattered (*oh no*).
2. Yes, he did love me (*lovely*), but wasn't attracted to me (*ouch*).
3. He hoped he'd find someone just like me . . . but not me (*oh, WOW*).

When I was in fourth grade, I was kicked **very** hard directly in the crotch by my friend Becky, and let me tell you, that was way less painful than this particular conversation with Greg.

I handled this Mother of All Insults with as much grace as I could muster as we sat on his rooftop deck. We had a kind conversation about how we both didn't want our friendship to change, hugged goodbye, and then Greg - - - dropped me like a hot rock. He stopped returning my texts and calls. Finally, he briefly told me on the phone that he didn't want to talk to me anymore and was very busy and didn't have interest in providing me with any further explanation. I was crushed. And confused. And very angry.

Two years later, after I'd long concluded that Greg - - - is a Grade-A turd, I received a very odd email from Greg "just wanting to say *hey*." **Hey.** I met Sean and his typewriter as I was pondering what would possess Mr. Grade-A Turd Greg to send an email with the subject line "Hey."

I explained to Sean how the email contained many oddities, like:

1. The greeting "Hey B" which has never been my nickname.
2. The meat of the email, just wanting to say hey (as predicted by the snappy subject line) and the mention of a great show he was currently in.
3. The very formal sign off: "All my Best, Gregory - - - ."

Why so formal? From top to bottom, I hated every word. In his poem, Sean managed to capture how strange, impotent, and tone deaf this digital drive-by felt, while including a whiff of the sting Greg left behind. I love the allusion to magic because I did feel like Greg - - - was magical once upon a time. But now I see clearly that the friendship was fake, and a bit of a predictable charade. *Ouch.*

DAVID:

FUTILITY

for Lowell Bartholomee & Ellie McBride

(Austin, TX)

Poet's Note: Ellie requested this one for Lowell at an event at Salvage Vanguard Theater. They're both theater people I've known for awhile, and Lowell was dealing with a writing crisis. Having a bit of experience with that, I wrote one that I later heard he found a lot of value in, and has hanging in his office.

Lowell: A few years ago, I'd managed to get myself involved with projects I really shouldn't have and the weight of those mistakes landed all at once—as it often does—in the days leading up to two deadlines. (Because, yes, I'd signed on to two projects that were due the same day.) My wife Ellie's burden during this time was to listen to me rail at the heavens for this particular chapter of life; one that on a global scale is nothing, but in the moment is all-devouring. I believe at some point I said, "I feel like all of my abilities are futile." And then I was off to put out fires.

At the end of that week, Ellie returned from an event and handed me a piece of paper with torn edges with lines obviously typed in glorious actual-typewriter type. "Futility" written at the top, initialed by the author at the bottom. Every line contained a perfect understanding of where my brain was that week/month/year and ended with a desperate prayer that also served as a small guide toward the escape hatch. It was as accurate and beautiful as any sixteen lines of verse could be. It was an entire trial, final argument, and surprisingly lenient sentence in so few words. It was the tiny seed that contained a universe.

That's when I learned how it was written. A made-to-order poem based on

Sometimes i look at my words on a page
and i wonder just what the damn use is
like some verbal train made of empty boxcars
wondering where its caboose is
been playing this game for so long
 it's a trap
a sinkhole or drain from my dreams
a place where all hopes and joys
 go to die
at least sometimes that's how it seems
all that i want, dear lord, is to serve
as a conduit, some kind of vessel
but i get in my own way, my light
all choked by the shadows i wrestle
but there's no greater worth
 no nobler path
than fighting to reach revelation
and so i'll plug on, no matter the cost
'till this train reaches Truth-in-Life
 Station . . .

a minimum of input from someone who was witness to a spiraling psyche that she was, nevertheless, bound to by law and heart. Am I surprised David was able to capture the thoughts in my head and offer a human plea/solution without talking to me? No. That's the magic creators pull off when they're at their best. They contain the knowledge and feeling of the full array of experiences and their particular brain and heart deliver the words/images/ movements/etc. In an instant, the poem became one of the greatest gifts I've ever received. It was an act of love from the best part of my life, delivered through one of the finest people I know.

I knew exactly how I wanted it preserved just then and ever since it's hung in the midst of my ever-cacophonous office; always prepared to understand and promise that there's always a doorway out. Or at least the hope of one.

L to R: Milly, Caroline, Sarah

SEAN:

MY DAUGHTERS

for John Kitchener

(Nantucket, MA)

Poet's Note: At the 2017 Nantucket Book Festival, John came up to our table and paused a moment, then spoke: "I'm not sure if you can do this, but can you write a poem about my daughters? Sarah's forty-two, Milly thirty-seven, and Caroline twenty-six. We lost Milly just over one year ago. This island was one of her favorite places."

John teared up as he was telling me this, and I didn't ask him for anything more, just said "of course," and started typing.

Most of the time people stay right in front of me while I'm writing their poem, but John walked off a ways, took a seat on a bench. When I'd finished, I got up, left the table, and delivered John's poem to him, then went back to my chair. With poems like that, it feels almost like an intrusion to watch people read them. I feel like, at that point, my time in their life is done.

```
MY DAUGHTERS
        (for John)

They say the island
    Never truly leaves you
        You can journey away
            Go to far off lands
        But still
            A part of it will linger
                In your heart
                    Calling you back

And so that is what it is like
    For me
        For us
            Coming here

And with Sarah and Caroline
    At my side
        We know that Milly
            Our dear, sweet Milly
Like this island she loved
            So much
        We know that she
            Will never
                Ever truly leave

                    Us.
```

I ran into John again later that day (Nantucket can be a small island). He gave me a huge, long hug, and told me how much he loved the poem. So did his daughter, Caroline, who was with him (she hadn't been when I wrote the poem). It's hard to describe what an honor it is to be part of people's lives like that, even for just a moment.

As we parted ways, John told me the particular spot where I'd typed his poem, the Atheneum Garden, had been Milly's favorite place on the island.

John: None of us believe that Milly has left us. She is just in a different place watching and being happy when she sees things like you typing that poem. You can be sure she was looking down on you and smiling, knowing what was in your mind and your words flying onto the paper.

SEAN:

ATTIC LIFE

for Frankie Furman

(Austin, TX)

Frankie: I received a custom poem, written by Sean, while attending the Blue Velvet Bash benefiting the Austin Chamber Music Center. The Bash was held at The Mansion, home of the Texas Federation of Women's Clubs. Being in this beautiful 1930s building had me thinking about a task that has been occupying much of my time and thoughts lately. I have been going through my parents' belongings in the attic of their last home. It has taken a very long time because every object brings a memory from my childhood. The decision to keep things or give things away takes a lot of time and thought.

I briefly described this scene to Sean, and the poem I received was amazingly true to me and my feelings. When my husband read the poem he was amazed. It was as if Sean knew me. Thank you, Sean, for a truly special poem.

Attic Life

Can you store a whole
 Entire life
 Up here, in just one room?

Can that painting
 Even begin to capture
 The magical brilliance
 Of my father

 At the canvas?

 Or does this fine piece
 Of China
 Even come close

 To showing what it was like

 When Mom cooked up
 One of her perfectly delicious
 Meals?

And all these photos and letters
 Snippets of time and lives
 And love
 All of it
 All of it
 Condensed into this one
 Special place

 And
 If I sit here
 With this soft
 Worn potholder

 I can almost feel her touch
 And if I look around
 Then close my eyes

 I can almost feel them both
 Right here
 In this room
 Full of time
 Lives
 And love.

"HOME"

poems of

FAMILY

(including PETS!)

We get lots of requests for poems about family. And, since most people treat their furry and feathered companions as family members, too, we've also included poems about pets (our most common topic of all) here as well.

PIPPA!

Oh who the heck needs two eyes

You can leap, bound
And frolick with the best of them

On one eye alone
And you can lean hard
Into my hand
Nuzzle and nudge
And purr louder ~~xxxl~~ and sweeter

Than any two-eyed feline
Around

And then
Just sitting there
Looking up at me

That great grand eye
Like the deepest of ~~jewlex~~ jewels

I can tell

Oh Pippa

That you
Only you

Can see right
Straight Into
My soul.

typewriterrodeo
.com

Custom
Poems

—Sean

BAXTER:

Oh xx I know, little guy
 I know
 That world out there
 Is so
 So
 Scary!
And it makes me want to hide sometimes, too
 Just curl up and escape it all
 In the cozy
 Safe comfort
 Of a shoe

From there
 Your little Converse cavern

 You can peek out
 Study the world
 And always know
 What's coming
And so I'll st ay here
 Right down here at your side
 Your sweet shoe buddy
 And, someday, when you're ready
 To go face that world
 I'll be here
 To help you along
 That first
 Fearless
 Step.

SEAN:

PIPPA! | BAXTER!

for Victoria Hudgeons

(Austin, TX)

Poet's Note: When Victoria came up to our table, she told me about her cat, Pippa, who she said was adorable and awesome. But she didn't really give me anything more specific, so I asked if she had a photo of Pippa. Victoria said of course, scrolled through her phone, then showed me the photo on the previous page:

"Oh!" I said. "How could you have left out the best part?!"

on the lights of my life: my cats. Specifically Pippa, a one-eyed, two-year-old, petite tortoiseshell princess.

The saying implies that any old picture is worth a thousand words. By that standard, I reckon a picture of Pippa is worth at least two thousand. Definitely enough for a poem.

Sean was visibly delighted by the photo I shared, and I knew he had that larger-than-life personality pinned down as soon as *PIPPA* was typed out on the title line like an all-caps exclamation. The complete poem gave me a teary eye (or two), and left me feeling so touched that I returned a few hours later for Sean to write an equally flawless piece for my other cat kiddo, Baxter, who has a cautious disposition and an affinity for shoes.

Both are cherished items in my feline household.

Victoria: One of my must-dos at the 2016 Texas Book Festival was the Typewriter Rodeo booth. I'd never heard of such a thing—writers coming up with poems on the spot, over and over, for hundreds of strangers who lined up over the course of a day. The concept alone was impressive enough to draw me in. At first I wasn't sure what topic to request, but I finally settled

JODI:
SECOND FIRSTS
for Paige Trabulsi
& Surabhi Kukke

(Dallas, TX)

Paige: My partner Surabhi was pregnant for the first time but with our second child. I gave birth to our first son, but I didn't have the experience of parenting while pregnant, so I felt especially appreciative of Surabhi, and wanted a poem to express that.

I remember feeling in awe of the poets—the line at the Dallas Museum of Art was SO long, and I thought it was incredible that they could bust out beautiful and funny poems so quickly. Geniuses!

Second Firsts

For the love who holds the new one tight inside
While wrangling the wise young friend
Who watches her body grow and ache
Stretch and twinge
Who needs to hunker deep
Explore this newest state
Yet also, always, yes
⁺s called to play and read and snuggle
And wrestle and cry
And all of it, all at once
Is so much more than allthe grandest muchness
of the world
Holding one inside
Holding oneself in this new wild state
And holding your boy
All of it.
"ith this, my love, you are all.

"Donovan + Tiny"

```
Have you ever seen
  Invisible string?
    No, of course you haven't
      ('cuz it's invisible)
But that's what it's like with those two
      Donovan and Tiny

Wherever he goes, she follows
  But not like she's pulled, oh no --
    Like she's curious, loving,
        Connected

  Into the backyard?
  You bet!
  Up in the treehouse?
  Let's go!
  Tucked beneath covers?
  The best.

  You may see, just a boy and his dog,
  Who adore each other
  To the ends of the earth
  But look close enough and you'll see it --
    That invisible string
      Between them
        That looks just like
          Love.
```

SEAN:

DONOVAN & TINY

for Michele Bodnar
Sabin

(Dallas, TX)

Poet's Note: While most of our poems are done at events, some are done as requests for gifts—holidays, weddings, etc. For Christmas 2014, Michele requested this poem about her son, Donovan, and his dog, Tiny. She told me they'd gotten Tiny two years ago and Tiny was all scarred-up from dog fighting, and they were a bit worried about how she would treat Donovan. But the two of them took to each other immediately, and have been inseparable ever since.

Michele: I wrapped the poem and gave it to my husband (Donovan and I already read it, it was perfect), and we all got teary!

JODI:

HOME

for Kathleen Avera Trail

(Austin, TX)

Kathleen: My parents, my brother, and I moved into our house in Houston on my second birthday in 1972, and I was convinced it was my birthday present ("My house . . ."). We had more than forty years of wonderful memories there; and when my parents started to think about moving, it was particularly difficult for my mom, who holds many family artifacts, toys, papers, and pictures dear. My parents were facing not only a move from that beloved space, but also with downsizing their belongings significantly. When my brother and his wife expressed interest in buying the house, it was perfect synergy—we'd all be able to stay connected to a place that had meant so much to us, but the house would have a new life with new stories to be told.

When the boxes are packed and gathered

And the corners double-checked

The air sparkles with dust

 Gathered over a lifetime

 of family and friends
 of gatherings and quiet evenings
 of laughter shared
 and struggles untangled

And this transition forward

Which also moves to the side

 Where home is not gone, just shifted

 Where the family will still gather at the table

 Where you may feel you're guest, not host

Know this--

 you are

 always beloved

 always welcome

 always, still, home

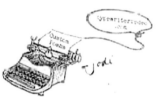

For the poem, I wanted something to honor the occasion and the history of my nuclear family's life in the house, and the bittersweet transition from that, but also to recognize that the house would still be an integral part of our family's ongoing story.

That Jodi could take such a huge experience and capture it in so few words is simply amazing. When I read the poem, I had tears of joy in the knowledge that all of the complex emotions my parents and brother/sister-in-law were feeling had been captured perfectly.

Watching my mom read the poem the first time was as joyful and emotional as when I first saw it—she was very quiet while reading it and for a few moments after, moved to tears. My dad created a special spot in their home to display it.

"The bus"

there is a thing
moving down the street
chock full of the craziest people
you could ever meet
theguy with thehair
thegirl with the face
theman with the slump
thelady's brace

the city bus is like a zoo
riding down the street
 barreling through crosswalks
better watch your feet

and when you get on
oh boy watch out
cause you never know
if they're going to let you out

just cover your nose
and hang on for dear life
youll get where you're going
with minimal strife

SIMON

A burst of sun
Upon his head?
That's Simon.

A hundred toys
Every one a bus?
That's Simon.

A perfect smile
That captures bliss?
That, oh that, is Simon.

—Sean

typewriterrodeo
.com

Custom
Poems

Kai Ave
2/13/15

SEAN & KARI ANNE:
SIMON | THE BUS
for Michael & Amy Armstrong
(Austin, TX)

Poet's Note: Sometimes, a picture writes the poem. That's what happened when Amy showed us this photo of Simon and Michael told us: "He loves busses."

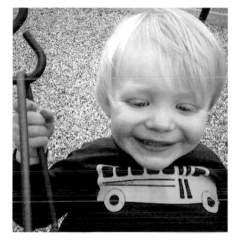

Michael: My wife, Amy, and I don't get out of the house much lately, and so it was a real treat to attend the opening party for the *Alice's Adventures in Wonderland* exhibit at the Ransom Center.

Once inside, the clattering keys of the Typewriter Rodeo punctuated the warm buzz of conversation, which made the experience take on a magical quality even before we received our poems. We stood in line. I quickly ran through a few ideas of inspiration as Amy and I talked about how much we missed our two-year-old son Simon. Neither of us could get Simon out of our heads. I realized I wanted to have a poem written for Simon, and his current obsession at the time was busses. Amy wanted to show a picture of our son to inspire the poet.

Kari Anne and Sean crafted two wonderful poems for Simon that delighted us while they typed them, inspired us once we read them, and to this day leave an incredible warm spot in our hearts.

When Simon gets older, we will give the poems to him framed and pass the inspiration along to him.

Memory Sword

I could slice every last champagne bottle
 And it wouldn't come close to being enough
 To celebrate the glorious weirdness
 Of this family

We, who've supported each other through the darkest hours
 Lifted each other up when xxx the night just went on
 too
 too
 long
Or cheered at a friend's greatest latest success
A film to share, a screening to host, a perfect seat
 snagged just in time
And oh,
 though we've torn the seats out of our oldest home
 No matter what bottle of champagne we open
 It's always got just a hint

 Of those oldest days
 With secret screening and sticky
 couches
 and 40s of malt liquor
 that never should have been
 All the days
 All the films
 All shared
 Always

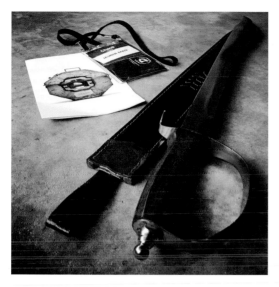
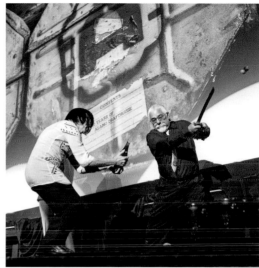

JODI:

MEMORY SWORD

for Jasmine Baker

(Austin, TX)

Poet's Note: The Alamo Drafthouse movie theater chain recently celebrated its twentieth anniversary. At a celebratory screening and party, each guest was gifted with a sword. A heavy, sharp, dangerously real sword. My husband and I have been part of the Alamo Drafthouse family since it was all of one year old. I loved getting the opportunity to capture the roller coaster emotions of this epic chosen-family reunion. Plus, nothing says "I love you" quite like opening champagne bottles with a sword.

Jasmine: In all seriousness, the poem took my breath away. And then I felt the roaring wave of yessss!

We bent time that night. What a homecoming for faraway old friends— and missing the ones who didn't make it. But I have a memory sword and can conjure them in my mind's eye. As we were. As we are.

DAVID:

THE ONCE AND FUTURE POUNCE DE LEON

for Eleanor Shaul

(Austin, TX)

Eleanor: "The Once and Future Pounce de Leon" is about adopting my new cat and hoping that no one would adopt him until I did. The poem always makes me cry!

Poem upon the Subject of

The Once & Future Pounce de Leon

for Eleanor

he's waiting there for us
 we can see him now

huddled in the litter box

or hiding in a corner

just waiting
 for the right humans
 to come along

and we really hope
 those humans
 are us

early signs are good

he came out of his shy cocoon
 and let us give him love

roommate troubles are going away

 and the landlady
 is warming up
 to the idea

 (we hoped)

someday,
 we'll look back on this time
 of waiting and wondering
 wishing and dreaming
pet our sweet kitty

 and be glad

fathers impart a lot of things
like how to do stuff
and make stuff
 and cook stuff
and be stuff
 but when they can tell you
the difference
 between a dwarf
 and an orc
when they can point out
 Marvel fallacies
 when they give you
 wheat buying strategies
you know that man
 oh man
 you've got yourself a good one
you've got yourself a father
 who canbe a dad
 and a friend
 and a leader
(and beca use you're lucky)
a wizard

KARI ANNE:

FOR RANDY

for Randy Lander

(Austin, TX)

Randy: This poem was my Father's Day gift in 2016. My wife Suzanne and I don't really do gifts. We have shared bank accounts for the entirety of our marriage, and we're both pretty practical people, so with rare exceptions, we don't surprise each other with gifts on our birthdays or at Christmas, much less Father's Day and Mother's Day. So when I get a gift from my wife, it means a little something extra, and when it's something personalized, by someone who knows me at least a little bit, it means just a little bit extra.

Suzanne: Holidays and anniversaries are important to Randy but while teachers always have kids do something cute for Mother's Day, there's rarely anyone thinking about Father's Day. I scoured everywhere for something meaningful for him and Typewriter Rodeo was perfect.

JODI:

LETTING GO

for Tracy Levins-Canning

(Austin, TX)

Tracy: Kate, my fourteen-year-old daughter, had recently been accepted into a summer study abroad program in Madagascar. Earlier that week, I'd returned the paperwork affirming that she'd be going. On the way to the bat mitzvah, it dawned on me what I'd done, and I was having selfish second thoughts about saying yes. I was deep in my head, reminding myself having strong, independent children meant that life would be a series of letting go.

At first it felt a little awkward—a little vulnerable and uncomfortably intimate—like the first day of seventh grade gym class when you had to shower in front of other girls. Soon though, I was gifted with words so powerful and so right-on-point that they felt as if they'd been wrenched from my heart and held up in front of me. Remember that scene from *Indiana Jones*?

A lump in my throat, a nod of affirmation, "Yes. Yes. This is precisely it."

I was most surprised that Jodi was able to craft such art in such a short period of time in an environment so rife with distractions.

Poet's Note: Sometimes I type a poem that ends up being one that I also need to read. . . . This one hit me at the core, as I'm watching my daughter crest into her teenage years.

Letting Go

It turns out that the mark of success
Is when you watch them from the back
Growing smaller in the sunset

Heading off to chart new paths
 Take new journeys
 Discover the world
 And discover all the ways they're going to
 Change it

And probably I should have seen this coming
The part in which I shift from holding tight
 to letting go

But the truth is
 No matter how strong I feel

 Their strength will be the tides

 And I'll let them go

 And I'll pull them close

 And I'll try to find the balance

 Again and again

 In love and through love

 But always ready

 To be a soft landing spot

For Roxie, and all those who love her

A fluffy blur tumbles past
Running off to sniff a rose
Then pounces in, jumps way up high
And licks me on the nose
Oh, Roxie, with your curly hair
Matted down with burrs
Never has a fluffy dog
Had such majestic furrrrr

We'll miss you so, our feisty pal
And so will all the bunnies
Lizards, birds, and baby owls
You made our days so sunny
Go frolic now, and know our love
Shines on, and clears the fog
We've go t a sweet spot in our hearts
For Roxie, our good dog.

Custom
Poems

JODI:

FOR ROXIE, AND ALL THOSE WHO LOVE HER

for Kerry Joyce

(Austin, TX)

Poet's Note: We're asked to write a lot of poems about people's pets—favorite pets, childhood pets, pets that have crossed the rainbow bridge. This poem has stuck with me because it was requested by a class of fourth and fifth graders in memory of their friends' dog, and as part of a collection to support the family through their recent loss.

Kerry: We lost Roxie unexpectedly one day after she had burrowed into our hearts for four years. She was a friend to all, especially to the kids at school. While dropping off my boys (ages nine and eleven at the time), I was asked to come into the classroom for a moment. There, the entire fourth and fifth grade classes presented us with a basket of goodies, photos, well wishes, and this poem. My heart exploded with grief and love and gratefulness for our beautiful, thoughtful community. Thank you, Jodi!

HAPPY FATHER'S DAY (from Blu)

You know
 If I ~~can~~ could make some words
 Come forth from this beak
They would be
 About how much I love
 Those maple-syrup mornings
 With you

And about how sweet it is
 (Literally)
 Spending those ice cream evenings
 With you
And about
 How all the rest of the day
 When I can free-fly

 Anywhere I want
Really
 The only perch I need
 Is your

 Soft shoulder

And so
 If I could say all that
 I would
 And of course
 I would end it all
 With a loud
 And loved-filled
 Thanks.

SEAN:

BLU | HAPPY FATHER'S DAY

for Ray Chimileski

(Nantucket, MA)

Leslie Chimileski: The Nantucket Book Festival is an event my husband Ray and I look forward to. The 2015 event was made special when I spotted Typewriter Rodeo. Poets clicking and clacking away. My husband Ray's birthday was coming up so what better gift for a man who wants nothing, but is obsessed with his pet lovebird named Blu? (We named him that because he is missing the color gene for blue.) I explained their complicated relationship to Sean, who then typed out a poem.

My husband cried when he read it; the words exactly captured Blu's spirit. We had the poem framed, and it hangs in our kitchen.

The next year we returned to the festival around Father's Day. I found Sean, and told him how much Ray loved the poem from last year. Then I asked for a Father's Day poem. I explained how we do not have children, so Blu is like Ray's child, and the two of them have waffles and syrup together every breakfast, and ice cream every evening.

```
                              BLU
        Sometimes it's the things that are missing
             That turn out to make life
                 The most interesting

        Just one tiny gene
             A mutation of beauty
                 That creates even more love
                     In a bird
                         Of the same name

        Some come here, Blu
             Perch right next to me
        Because when you're here

                     Nothing's missing
                         At all.
```

Sean's poem about "maple syrup mornings" was my Father's Day gift to Ray. He cherishes it and had it framed, too. Ray's poems have been the perfect gifts for a person who wants nothing but love.

For Elliot

If you looked in the dictionary
Back in the day
under Mom,
I don't know that you'd see me there
Oh, I had visions of what that'd be
And it involved a whole lot of whining and poop
But then
There was you
And here's the thing--
There's a whole lot of whining and poop
But holy goodness if you are notjust the bx
_best thing I ever did
And my biggest love, and my heart
You've changed my definition of me
And I'm a tumbling swirling swooning tangle
of love
for you
my boy

JODI:

FOR ELLIOT

for Jen Rios

(Buda, TX)

Jen: I was attending an exhibit opening at the Harry Ransom Center when I had my Typewriter Rodeo experience. I had left my three-year-old son Elliot at home that evening because I had to attend the event for work, and he was on my mind (as he usually is).

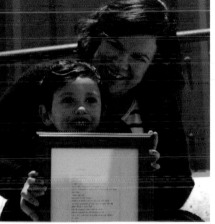

I've always been fascinated by old typewriters, so I was drawn to the table. I stopped up and was greeted warmly by Jodi, who asked what I wanted her to write about. "My son," I said. "He's three and his name is Elliot. I was never really sure I wanted to be a mom, but he's the best thing I've ever done."

With that small little nugget of information, Jodi crafted a poem that was beautiful, funny, and heartfelt. It also perfectly reflected my feelings toward my son. I looked at her with tears in my eyes after reading it and all I could say was: "Thank you. It's perfect."

The poem is now framed and hanging in E's room. I will always treasure it.

JODI & SEAN:
BRIDE BOOBS | FUTURE YOU
for Andrea Wofford

(Austin, TX)

Andrea: Jodi is one of my most special friends. So, when planning my wedding last year, I knew Typewriter Rodeo needed to be a part of the celebration. The outdoor ceremony ended up being a wet one, with a Texas-style downpour in the middle of it. Undeterred by the rain, Jodi and Sean set up under a pavilion after the ceremony and started typing away.

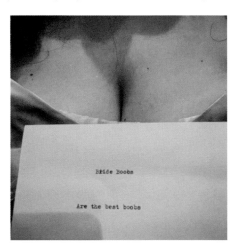

The night was flying by, and I realized I hadn't requested any poems yet. I leaned over the table in my soaking wet bridal gown to ask Jodi for a poem. Before I could describe the subject, she held up her hand and said, "Wait, just a second." She scrolled a piece of paper into her typewriter and quickly typed, "Bride boobs are the best boobs."

I hadn't even noticed how prominently they had been on display while leaning over to talk to her. A friend took a picture of me holding the poem, and it remains one of my favorite photographs from the wedding. Jodi and Sean went on to type well into the night, and our guests absolutely loved their poems. Some guests requested poems for my husband and me as gifts, which were touching and fun to read in the days that followed.

A few months later, we attended an event where I knew Typewriter Rodeo would be typing. I started thinking well in advance of what subject I'd request. Many months had passed since our wedding, and Erik and I were expecting our first child.

When it was my turn, I gave Sean my subject: expecting a baby Jedi. His face

Oh with that kick I know
 The Force is strong
 In the one
And with that feeling I know
 That even with my eyes closed
 With my blix blast shield down
 Oh I could always find
 You
You
 Growing quietly
 (Okay sometimes not so quiet)
 Inside
You
 Soon to be here
 Learning
 loving
 All
Oh yes with you I know
I am as sexxt certain as the galaxy
 That you
 Will be my sweet
 Strong
 Little Jedi
 Of love.

lit up as he worked in each *Star Wars* reference. He was clearly the man for the job. When he finished the poem, I showed it to Erik so we could read it together. We both teared up as we read the first line. It was the ideal poem for our son, Luke.

The poem is now framed and was the first piece of art we hung on the nursery wall. Not only did Typewriter Rodeo help make our wedding special, but they gave us the gift of a poem representing the highly anticipated next stage of our lives. Jodi, coincidentally, was one of the first people to meet Luke, as we were fortunate enough to have her as our doula at his birth. Seeing that poem on the wall every day is a reminder of those special times in our lives and of the wonderful magic of poetry.

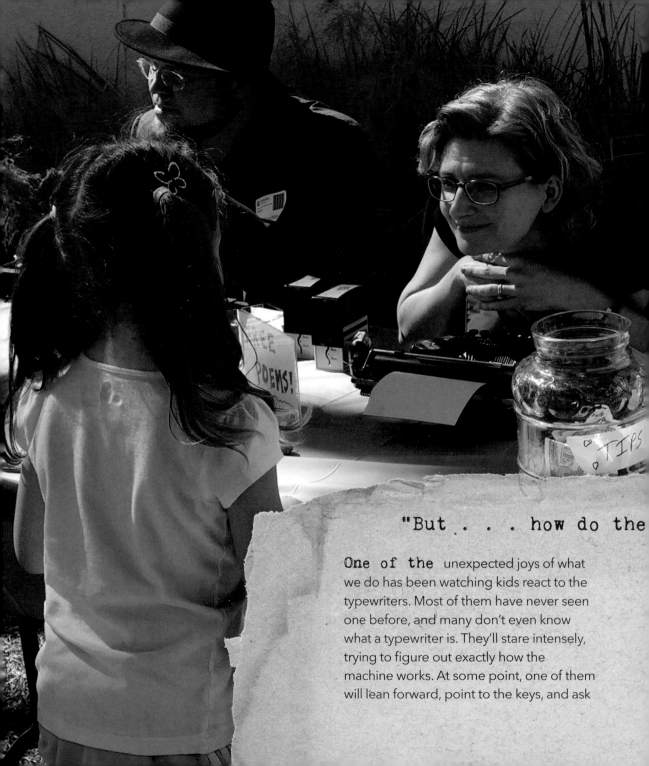

"But . . . how do the

One of the unexpected joys of what
we do has been watching kids react to the
typewriters. Most of them have never seen
one before, and many don't even know
what a typewriter is. They'll stare intensely,
trying to figure out exactly how the
machine works. At some point, one of them
will lean forward, point to the keys, and ask

"SILLY ANIMALS"
poems for KIDS

letters get on the paper?"

something like, "But how does it do it? How do the letters get on the paper?"

In response, we'll typically say each letter is like a tiny stamp, then rub our fingers across the ribbon, to show that it's full of ink. It never gets old, watching those faces light up when they "get" how a typewriter works for the first time.

And, of course, the poem requests we get from kids are some of the most fun. We've been lucky enough to type for kids at schools, libraries, book festivals, craft fairs, children's hospitals, and museum family day events; here are some of our favorite poems and stories from those.

SEAN:

FOR IAN

for Megan & Grayson Hall

(Dallas, TX)

Poet's Note: Whenever I get a poem topic, I love the fact that it often makes me look at something in a new way. And, most of those times, I have no idea what that new angle will be—I just type and see where it leads. That's particularly true when someone gives me two unrelated topics to weave into a single poem.

At the Austin Flea craft fair in December 2014, my friend Carrie came up to our table: "Can you write one for my nephew, Ian? He's five and he loves anglerfish. And ghosts. Can you work both those in?"

Megan: We loved this poem so much when we received it as a Christmas gift! Back when we had Ian, people always said, "Write down all the little things, because you think you will remember them . . . but you won't." This poem meant so much to us, and still does. Every time we read it, it brings back our quirky little five-year-old boy. Because before there was Minecraft and game consoles and YouTube . . . there were ghosts and anglerfish.

For Ian—

Deep deep down
　　In the darkest of depths
Lurks the greatest of fish
　　Far away from the nets

Don't dare get too close
　　To those bright hanging lights
Don't mess with the angler –

　　'Cuz the angler, he bites

Oh deep down in the depths
　　Glows the one I love most
He's one part fish
　　And one part – ghost.

M.M.　(for William)

sitting at the center

of his vast underground lair

the most powerful rodent

in the world

thinks about his life

as he pulls the strings

that control so many movies

and parks

and rides

and people

and money

it's lonely sometimes

to be the boss

he thinks about the good times

with his girl, and the duck

the dog that talked, and the one
 that didn't

when they were young and scrappy

now they only see each other

on facebook

the mouse sighs, wipes away
 a tiny tear

 and gets back to work　-david

DAVID:

M.M.

Poet's Note: Once
we start typing a poem,
the muse takes over and
we don't necessarily
have control over
what comes out of the
typewriter. This one was
for a young man, age
eleven perhaps, who
approached our table
and innocently asked for
a poem about Mickey
Mouse. What resulted
was perhaps the most
age-inappropriate
poem I've ever written.
Sorry, kid.

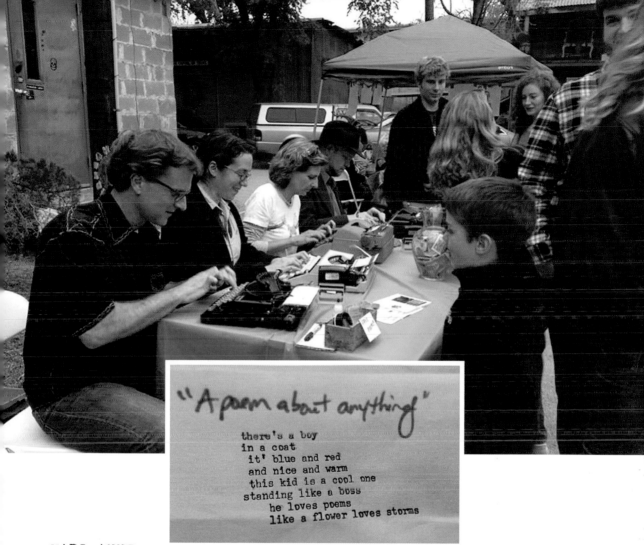

"A poem about anything"

there's a boy
in a coat
it' blue and red
and nice and warm
this kid is a cool one
standing like a boss
he loves poems
like a flower loves storms

KARI ANNE:

A POEM ABOUT ANYTHING

Poet's Note: At some gigs, we'll get repeat poetry customers. At this particular one, a school fundraiser, there was a boy who got at least four different poems, one from each of us. He would get a poem, show it gleefully to his parents, then come rushing back to our table for another. When it was my turn and I asked him for a topic, he proclaimed, "Anything!"—as if, no matter what I wrote about, he would love it.

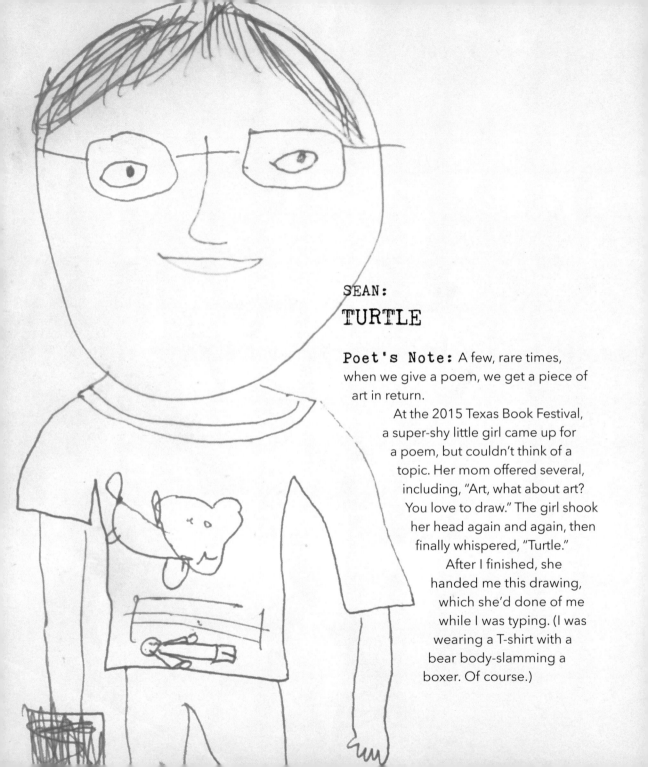

SEAN:
TURTLE

Poet's Note: A few, rare times, when we give a poem, we get a piece of art in return.

At the 2015 Texas Book Festival, a super-shy little girl came up for a poem, but couldn't think of a topic. Her mom offered several, including, "Art, what about art? You love to draw." The girl shook her head again and again, then finally whispered, "Turtle."

After I finished, she handed me this drawing, which she'd done of me while I was typing. (I was wearing a T-shirt with a bear body-slamming a boxer. Of course.)

TURTLE

He seems so shy
 All hunched there in his shell
 Sometimes peeking out

 Slowly, carefully
 Other times ducking all the way inside
 Like he just wants a bit
 Of alone time
 And I get it
 I totally do
 ~~Bwks~~ Becuase I'm the same way

 Sometimes I'm great peeking my head out
 Smiling and chatting and being around
 Everyone
 But other times?
 Other times I just want to be

 With me
 Just here with my thoughts
 ~~Myebbeeer~~ Maybe a good book
 Or a nice sheet of paper and a pen

 To do some drawing
 Yup sometimes I need my alone time, too
 And though you can't see it

 It's there
 My invisible turtle shell
 There when I need it

 There to help me be
 Me.

123

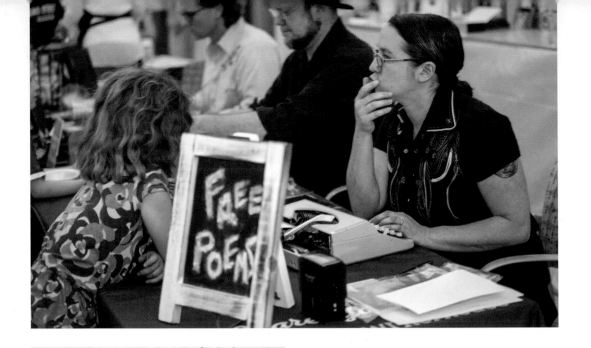

Silly Animals

The cockatoo is cockamamie
The duckling quacks and qu acks
The standard poodle has funny groomed fur
The pigeon steals your snacks
The blue-footed booby has big blue feet
They're webbed and flappy and bright
The firefly's probably the silliest of all
With a bottom that bxx glows with light
Of all the animals on our big earth
The ones that have the most fun
Are the silliest, wackiest, wonkiest creatures
That we know as the human

JODI:
SILLY ANIMALS

Poet's Note: Typing poems for kids often brings out the silly in me. I mean, it doesn't take much to do it anyway, but having a kid standing across from me, giggling and giving me some crazy topic, I can't help but put a little (or a lot) of that uninhibited goofiness right back into their poem.

This one was from a family day event we did at the San Antonio McNay Art Museum.

It's hard
 Sitting here
 Trying to put in mere
 Words
 What you meant
 What you did
 For all of us
Sure, they were just songs
 But no
 They were so much more
 A swagger
 A life
 Embraced
A man
~~Who seemed to~~
 Who seemed to float above
Yet still connect
 With every
 Single
 One of us
Because you can hear those songs
 You will hear those songs
 For the rest of forever
 And they will make ~~em~~ you shake it
 Make you sing and squeal and scream
 With the giddiness
 Of simply being alive
 And for now
 Also
 Will make you celebrate
 With a shiny
 Soft
 And timeless
 Purple tear.

SEAN:

PRINCE

Poet's Note: I've never said "no" to a poem topic. But this was the closest I came.

On April 22, 2016, we did an event at the Ann Richards School for Young Women Leaders in Austin. It was the day after Prince had died. A girl, probably in seventh or eighth grade, came up to the table and simply whispered, "Prince." I paused, leaned back. "Oh man," I said. I almost added that I couldn't do it, that it was too soon, too raw.

It seemed like Prince had always been a part of my life—through middle school, high school, college, and beyond—he was simply always popular. His death hit me harder than I would have expected. So, when she asked for a poem about him, I felt this well of emotion and wasn't sure if I could do it.

But instead I nodded to her, like we were both sharing a moment of grief, then put my head down and wrote.

"Friends"
 together we march
 hand in hand
 (or at least mind in mind)
 and our mouths are pink
 blue
 red
 purple
 or tongues are cold
 while our cheeks are hot
 and this day
 is also full of hot and cold
 shivers down our spines
 from beautiful words
 and fires in our bellies
 sparking the need
 to tell our own stories.
 friends
 writers
 sweet cold ice
 everything you need
 for a perfect day
 a perfect moment
 together

KARI ANNE:

FRIENDS

for Lucy Podmore

(San Antonio, TX)

Lucy: The poem, "Friends," was written by Kari Anne to capture the experience of attending a book festival with fellow book lovers. It was written for three young friends, Neriah Olivier, Bella Podmore, and Rosa Acevedo and captures the public joy they experienced when celebrating their love of reading, which can oftentimes be a solitary experience.

The poem brings back memories of a beautiful April day, of snow cones, books, friends, and good times.

"my dead doll"
(for my daughter Amelia)

my doll, she died the other day

it made me very sad

i wish i hadn't had to kill her

but she was very bad

she never did a thing i said

she picked on all the others

the meanest doll you ever saw

to her sisters and her brothers

so i had to put her down, it was

the hardest thing to do

and now she's risen from the grave

QUICK, RUN BEFORE SHE KILLS YOU TOO!!!

— david

DAVID:
MY DEAD
DOLL
for Amelia Rose
Duende

(Austin, TX)

Poet's Note: This is one I wrote for my daughter when she was eight, I think. It illustrates something about our relationship, I'll say that for it.

BABY GOATSX WEARING SWEATERS

Oh look at that crew
Of little baby goats
Are they the cutest?
They are -- totes!

Yup look at them all
Around their dad, Billy
But wait, do they shiver?
Are those baby goats, chilly?

Well quick, let's fix it
Get 'em out of this weather!
Give each little kid
Their own knit sweater!

Ah, much better
Wrapped up, like kid sheep
Those goats have stopped shaking
And now, time for sleep.

SEAN:

BABY GOATS WEARING SWEATERS

Poet's Note: When I get a topic, really the only thing I decide right away is—will this poem rhyme? If it's a fun, whimsical topic, often the answer is yes. If it's a heavy, personal topic, the answer is nearly always no. But for the rest, I just go wherever my instinct first leans.

This poem came from the 2016 Nantucket Book Festival, when someone (I think it was a little girl, but my memory of the request is a bit hazy) asked for a poem on "baby goats . . . wearing sweaters!"

I knew immediately it was going to be a rhyming one, and I launched in. After I finished, I snapped a photo of the poem before handing it off.

It's still one of my favorites to read aloud, especially when we do school visits or poetry workshops for kids.

DAVID:
DINOSAUR POEM

Poet's Note: We get poem requests about every topic under the sun, and some that lie beyond it. I'm a huge science nerd, so some of my favorite poem topics deal with science in some way, shape, or form. Here is one along those lines that particularly struck me as a "Eureka!" moment.

Dinosaur Poem (for Chris)

remnants of them remain

in the shapes of birds
 tiny geckos
 Gila monsters

but in my dreams
 i live in the age
 of those enormous terrible lizards

(which i know
 people never did
 but i can dream)

the lords of the planet
 in their day

and in my dream
 they have allied with human beings

trading their strength and ferocity

for our technology
 and clever little hands

we've brought them ice cream
 enormous motorcycles
 and the internet

tyrannosaurs in particular
 love twitter

while your typical pteradon

is more of an instagram
 sort of reptile

and then i woke up, but somehow

i still feel my dream is true

 somewhere...

— dav.d

They say that anything great
Anything super-awesome
Can never
Never truly
Last
That the golden shine will fade
That the pluck of youth
Will slow with time
That the magic of dreams
Will become crusty
With reality
And you know
It's true.
But here's the thing
If you're always holding on
To that great gold thing
Always trying to keep it today
As great as it was yesterday
You will always
Always
Lose
Because it's true
Nothing gold can stay
But it's also true that there's a ton
Of gold
Out there in the world
Always a new ~~xxxxxx~~ nugget
Waiting to be found
And one of the best pieces of gold
Of all
Is change.

SEAN:

NOTHING GOLD

Poet's Note: Sometimes the deepest poem requests can come from kids.

A young boy, probably eight, came up to our table at the 2015 Texas Book Festival and said, "My favorite poem is 'Nothing Gold Can Stay.' Can you write me something about that?"

I balked for a second, that someone so young would have that as their favorite poem, but then—like we always try to do—I treated what he'd just shared with great respect.

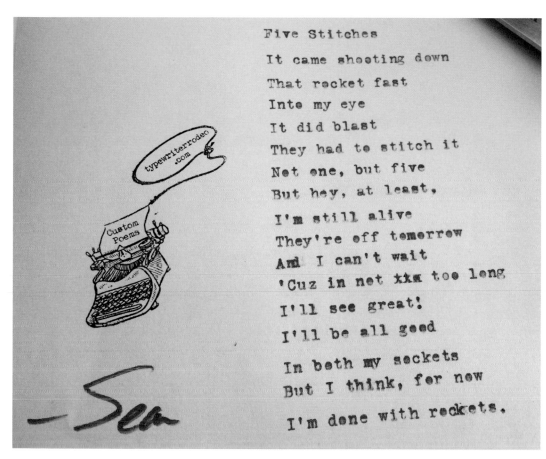

Five Stitches

It came shooting down
That rocket fast
Into my eye
It did blast
They had to stitch it
Not one, but five
But hey, at least,

I'm still alive
They're off tomorrow
And I can't wait
'Cuz in not too long
I'll see great!
I'll be all good

In both my sockets
But I think, for now

I'm done with rockets.

—Sea

SEAN:
FIVE STITCHES

Poet's Note: At the 2014 Texas Book Festival, a boy, probably seven or eight years old, came up to our table with his family. The boy had a huge bandage over one eye, but I didn't say anything about it, just asked what he'd like his poem to be about.

"This," he said, pointing to the bandage.
"What happened?" I asked.
"Bottle rocket," his mom answered. "Hit him right in the face."
The boy nodded to confirm, then grinned big. "I got five stitches. They're taking them out tomorrow."

"let your LIGHT SHINE"

poems of Inspiration

"Let your light shine"

```
your light is yours alone
 and even wh en someone says
aaaahh that 's too bright
   turn it down
   my eyes
MY EYES
you can say
   hey
   take these sunglasses
   take this shade
   in fact
I 'll throw this shade
   right at your face
    because this light
     it 's mine
   and for fuck 's sake
    I 'm going to let it shine
```

KARI ANNE:
LET YOUR LIGHT SHINE

Poet's Note: Maybe it shouldn't be surprising, but I am always a little shocked at how many people keep vision boards. We get a lot of requests for inspirational poems that can go on a vision board. Some deal with confidence, others with adventure or reaching a new chapter in life. But this one was a little different. This request came from a woman with a defiant sparkle in her eye. She didn't elaborate on why she wanted "Let your light shine" to be her poem topic, other than that she wanted it for her vision board. It's hard to describe how sometimes you can tell exactly what a person needs to hear just by looking at them, but when I looked at this woman, I knew. She had a light, dammit, and she was sick and tired of people trying to dim it.

Truth, Courage, Love

There's that moment
 where you just think you cannot

 cannot

 go any further

Where the ground feels quick and draggy

 You're going under and there's no energy left

 to pull yourself out

This. This moment, this is your power.

Where you dive deep,
 hunker down,
 reach out

And find all of us out here, ready to lift

Ready to help you scramble up
 climb out,
 thrive

When all seems too much, your truth is your power

When all seems too much, your love, oh, such power

And when even then it's too much, you've got us

 Take the leap

 You are safe
 loved
 brave

JODI:

TRUTH, COURAGE, LOVE

for Muna Hussaini

(Austin, TX)

Poet's Note: Muna gave me three words for her poem topic, but she also gave us so much more in terms of inspiration and strength. She was one of our earliest and most enthusiastic supporters, and it was an honor to write this poem for her.

Muna: I was moved to tears by this poem. Typewriter Rodeo is made up of the most brilliant minds, beautiful hearts, and vintagey typewriters, and they click-clack out love like I've never seen. This poem, this gift, is *MAGIC*.

Muna Hussaini,
"No Ban, No Wall" rally,
Austin, TX, 2/25/17

SEAN:

EMPTY POCKETS

for David MacVane

(Portland, ME)

Poet's Note: Sometimes people will try to tell a friend what their poem should be about. But getting a poem is often personal, and we've found it's almost always better if someone picks their own topic.

At a small coffeehouse in South Portland, Maine, our table was near a group of "regulars," all in their seventies and older. One of them pointed to the

Dave, on board *Empty Pockets*

guy sitting beside him and said, "Dave here is a lobsterman. You should write him a poem about lobster."

Dave didn't respond, other than taking a sip of coffee. "Is that what you want?" I asked him. "A poem about lobster?" Dave shrugged, then gave me a less than enthusiastic, "I guess."

I waited a moment, not sure if it was a good idea to type him a poem at all.

Then Dave leaned toward me and said, "My boat was called *Empty Pockets*." He didn't say it as a poem request, but rather like he was just sharing a bit of information. I nodded, then started typing.

After Dave read the poem, he grinned. "You didn't know me at all," he said, "but this is right on." Then he went around the cafe, table by table, enthusiastically showing the poem to his friends.

He also told me a bit more about himself and his boat.

Dave: I was a lobsterman for seventy-five years. I had lots of boats. *Empty Pockets* was my last one. I sold it a couple months ago. The hardest thing was watching that boat pull out of the harbor the last time.

136

EMPTY POCKETS
(for Dave)

Sometimes you pull up those traps
And they're filled to the brim
More lobster than any one person
Could eat

But other times
Most times, really
It's just you and that flat sky
Those rolling waves
And that chill that seeps
Through all

And this is why you do it
Why you come out here
Day after beautifully cold day
This time
When it's just you and the sea
Because even when your pockets
And traps
Are empty
Your life is still
Full.

typewriterrodeo
.com

Custom
Poems

—Sean

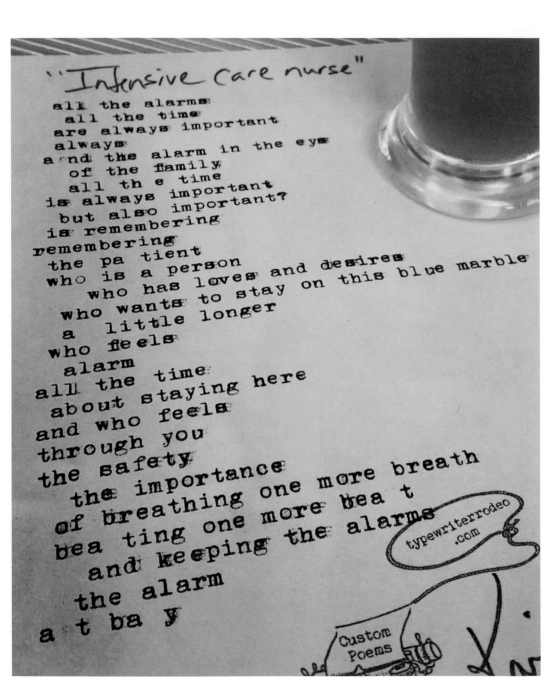

"Intensive care nurse"

all the alarms
 all the time
are always important
always
and the alarm in the eye
 of the family
 all th e time
is always important
 but also important?
is remembering
remembering
 the pa tient
who is a person
 who has loves and desires
 who wants to stay on this blue marble
 a little longer
who feels
 alarm
all the time
 about staying here
and who feels
through you
the safety
 the importance
of breathing one more breath
bea ting one more bea t
 and keeping the alarms
 the alarm
a t ba y

typewriterrodeo
.com

Custom
Poems

138

KARI ANNE:
INTENSIVE CARE NURSE
for Whitney Lowther-Franco
(Austin, TX)

Whitney: The intricacies of working in an intensive care unit are not easily understood by most people. Explaining nursing, especially my kind of nursing, to people is sometimes very difficult to do because people usually have to go through it to understand it. When I stumbled across Typewriter Rodeo and had this poem written, I was at a beer festival. As soon as I read this I stopped in my tracks and cried. I read it over again at least three times and was completely blown away by how perfectly the ICU experience was summed up on that little piece of paper. I proudly display it on my locker at work and routinely hear "wow" uttered a few seconds after someone will stop to read it themselves. It's a powerful reminder of the human side of modern medicine.

Poet's Note:
We never know who's going to walk up to us at an event, and we never know their topic. When Whitney approached me and said "ICU nurse," I was immediately transported back to the harrowing months my youngest son spent in intensive care as a baby. During that time, I marveled over our nurses. They kept me calm, they kept him safe. They never panicked, and they were so compassionate. It was an honor to be able to write this poem—a shared moment neither Whitney nor I knew we'd have that day.

SEAN:

I'M HERE

for Susan Simon

(Hudson, NY)

Poet's Note: When people give us topics, it's often *how* they say the words that matters as much as the words themselves. When Susan came up and asked for a poem, she only told me, "age, and invisible." She could have said "invisible" proudly, like it was a superpower. But she didn't; the way she spoke, I sensed what she was really asking for her poem to be about: "Being old and feeling invisible."

Susan: I was on Nantucket Island, my sometime home, for the annual Book Festival. I had just finished listening to a well-known author, and I had forty minutes to spare until the next program. I noticed—actually, I *heard*—the clickety-clack of typewriters set up among the roses in the Atheneum garden. The sign said "free poems." Now there was an irresistible offer.

I lined up behind twelve or fourteen people, watching the poets working at what seemed like mach speed. When there were just three more people before my turn, I realized that I would need to give a little hint about the subject of my poem—the Rodeo typists were poets, not mind readers.

I'd been thinking about relevancy, on and off, for the past few years; the business that I owned, the books that I've written, the places that I've lived, the other language I speak, travels, meals, love . . . Often it seemed that those experiences—that were asking to be shared—weren't relevant to anyone but me. Is it my grey hair?

My turn arrived. I stood in front of Sean and said "age" and "invisible."

He typed, smiled, sat back a moment, continued to type—then gave me this poem.

When I posted it on Instagram, my friend Simon immediately commented: "@typewriterrodeo nailed it. SS [Susan Simon] to a T."

He was right. They are poets *and* mind readers.

I'M HERE

(for Susan)

Those cobwebs up there
 The ones that have been slowly forming
 Over time
 Most folks never even notice them
 Until they absolutely
 Have to
And then they get swept
 Quickly
 Aside

 But
 If you take the time
 To stop and pause
 In your oh-so-important lives

 All you people
 Might notice
 How the sunlight
 Catches those crotchedy webs
 ~~Sprxkx~~ Sparkles and shines
 Into a fancy fiery filigree
 Of unique
 Beauty
And that's how I am
 Standing here
 In the cobwebby corner
 Of your life
 If you just stop to notice
 The brilliant
 One-of-a-kind complexity
 Of me.

"Happy birthday, Sally"

```
       ride, sally, ride
       they say the sky's the limit
       but with you it never was
        riding a rocket
     you became a beacon
        a firework
     a spark for every young girl
        a new path of light
     for every darkened mind
        you opened up our world
   by leaving it
        by lassoing a tinderbox
           and pushing through
        so many ceilings
        you opened up new worlds
     for so many
        so many
        little girls
```

KARI ANNE:
SALLY RIDE

Poet's Note: Sometimes no one requests a poem . . . a poem requests a writer. There's a half-heard news bite on the radio, or a Google Doodle, or a conversation overheard in a restaurant. And sometimes, there's a quiet moment of reflection before a typing gig when it's time to test the ribbon and flex your brain. You exhale and write your first poem of the night. On this particular night, my thoughts wandered to a brief NPR story I'd heard earlier, celebrating Sally Ride's birthday.

In the summer before second grade, three months before my seventh birthday, I stood in my backyard and watched Challenger's STS-7 mission rocket to space. Sally Ride was about to be the first American woman in space. I watched the thick plume of steam climb higher and higher in the sky, and couldn't quite wrap my head around the fact that there were people riding that rocket. Actual people! Going to space! While I watched! From my backyard! Sally was making history while I swatted ants off my toes. I marveled at that fact when I was six, and I've not stopped marveling since.

We all have heroes. And on that day in 1983, a lot of little girls (and big girls) found a new one.

JODI:

BLOOD SUGAR

for Rachel & David Wyatt

(Austin, TX)

Poet's Note: Sometimes I write a poem, and then it comes back around with whole new meaning in my life.

In the fall of 2016, I wrote this poem for David and Rachel, who've been wrangling their son Miles's type 1 diabetes (T1D) for most of his young life. My husband Owen also has T1D, and he and Miles bonded way back when Miles was in my son Oscar's preschool class when they were two years old. I've often thought about how much harder it is to have a child with T1D—Owen was

diagnosed at age thirty, three weeks after we got married, so he never experienced a childhood with T1D.

Flash forward to February 2017, where Owen and I found ourselves rushing our eleven-year-old daughter Arden to the hospital after some concerning symptoms led us to test her blood sugar using Owen's glucose meter. Normal blood glucose levels range from 70-120. When we pricked Arden's finger, the meter read 325. Our world froze, we held our breaths, hoping we were wrong,

Arden, at her initial
hospital visit

```
                    Blood Sugar
I'm watching you checking
                          And come up with a fist bump
Your levels are better than mine

But that moment it flashes

    A smooth 96
                Aw yeah--you know you're divine

And sure there's that moment
    You realize you're dropping
        You're scrambling off for some juice

And the patience,
                waiting for all to resolve
    Where your hunger just feels on the loose

But here s the true thing--
    We are rocking this, friend
            Though it never was part of our plans
And we'll weather the lows and those swirling highs too
    As we take the wheel wheel for our islets of
                                        Langerhans
```

but with a second similar reading, we knew what we were facing. Thankfully, we had our Typewriter Rodeo family ready to help—Sean raced to our house and spent the evening with eight-year-old Oscar while we took Arden to the hospital.

After three tumultuous days, slowly embracing our new reality, we posted a long note on social media to share Arden's diagnosis with our greater community. We were immediately wrapped up in love and support.

And then Rachel and David reposted this poem I'd written, a poem that suddenly was mine too.

Rachel: Jodi captures the constant flux of blood sugar so perfectly. Big hugs to her and her family while they adjust to their own new T1D diagnosis. It's not something I would wish on anyone, but knowing we are all here managing this thing together gets me through many days.

145

SUNFLOWER

(for Cydney)

Some flowers
Just like to play it cool
And lay low
But oh
Where's the joy
In that?
No, gimme that tall
Proud stalk
The one that's not afraid
To stand out
And tower over
Life
And give me that bright
Bold face
That instead of playing it cool
Always turns to
The warmth
Yes, you can have all those other
Little flowers
And me
I'll take the one that
Just like I do
Stands x tall
Proud
And happily radiating
Every
Single
Day.

SEAN:

SUNFLOWER

for Cydney Gray

(New York, NY)

Poet's Note: A big part of what we do is simply reading people. Yes, listening to their words, but also paying attention to everything else. When Cydney came up to the table at an event in Brooklyn, she simply said "sunflower." Cydney was tall and confident, with a shock of bright hair, I knew her poem was going to be as much about her as about the flower. I didn't ask her anything more, just started typing. Most of the time when I'm writing an on-the-spot poem, I keep my head down until I'm finished. But I remember with Cydney's, I would occasionally pause, glance up at her, get a flash of inspiration, then keep going.

Cydney: Over the past couple of years, I have been intentionally taking the time to learn more, question everything, and separate my version of "me" from the "me" other people expect me to be. A huge part of that process has been figuring out my relationship to spirituality. I grew up generic Christian but I've covertly identified as a solitary witch for the last eight years. My practice included meditating, working with the moon, developing a pretty strong tarot practice, reading people's astrological charts for fun, and laughing when my friends called me "bruja." But, it was never really something I shared with others or anything that I did outside of the comfort of my own apartment.

Sometime around the fall of 2014, my research led me to African spiritual practices in the forms of Santeria, Quimbanda, and New Orleans Hoodoo and they just felt right. The spirit that

147

stepped up first was the Orisha Oshun, goddess of the river and fresh waters. Oshun is a wonderfully multifaceted deity but the short list of her responsibilities include sensuality, fertility, pleasure, witchcraft, divinatory practices, and justice. In the Yoruba/Cuban religious faith, Oshun is associated with the color yellow, gold, copper, brass, peacocks, bees, honey, mirrors, roses, the number five, and sunflowers.

As I began to research and develop a solitary, careful, and respectful relationship with Orisha worship and Santeria, I started seeing Oshun's footprint everywhere. All of a sudden I was inundated with peacocks and the color yellow every place I went. Every number had digits that added up to five. Bees started following me around whenever I was outside for more than fifteen minutes. (One stung me on my tongue on a day I was being stubborn, but that's another story for another day.) All of these external signs made me turn the mirror on my internal world and notice little things like how I put honey on everything instead of sugar, yellow roses were all over my apartment, my favorite jewelry and dresses were gold, and big things like so many aspects of my life uncannily mapped to the traditional myths about Oshun. It was as if she had always been around and was just waiting for me to notice her.

The sunflowers were the last of Oshun's signs to show. They came with a year of losing a parent and another close family member, falling in love, finding an amazing godparent and Santeria/Quimbanda family, being officially told I'm a child of Oshun, fighting for equity as a person of color in some of the most oppressive/privileged spaces I've ever experienced, and building a culture of love and respect among a small school's worth of teen and professional artists. Sunflowers came with being visible, being vulnerable, learning to love unconditionally with accountability, being able to cry in public, and daring to laugh at the world that wanted me to be something that I'm not. Those bold, bright flowers became a reminder to stay open, keep living, keep shining, keep trusting my path, and to remember that the sun, like Oshun, was never too far away.

When I met Sean typing poems in Brooklyn, giving him the subject "sunflower" was pretty easy. When I read the poem he wrote, I smiled, cried a little, laughed, and thought "how did you know?"

"Planet"

```
          big ol sphere
       han ing out
         like what up
     im a sphere
          and im in the sky
          and im a billion jillion
             years old

        but really
          none of that is impressive
          o, sphere
          because you have  no atmosphere

        and you cannot support life

             im a lady
             and i can support so much life
      i have a billion jillion
          biomes
       so yeah
          think about that, planet
             think about that
```

KARI ANNE:

PLANET

Poet's Note: We were at the Texas State Capitol, typing as guests of the Texas Book Festival, when a woman who had waited in line for a long time finally made her way to the typewriters. She had two little girls in tow, a bag of books, and a "Come and Take It" t-shirt.

In Texas, the "Come and Take It" slogan is very popular. At the Texas State Capitol, where there is almost always a protest taking place, it's particularly prevalent. It also spans all sides of the political spectrum. This woman's shirt, rather than showing a cannon or an assault rifle or a pencil, showed a uterus.

"What would you like your poem to be about?" I asked the woman and the girls.

"A planet!" one of the girls said with a grin.

"Being a lady on _this_ planet," the woman said.

"Life," the other little girl offered.

"I can do that," I said.

SEAN:

FOR FRANCES

for Frances Smith

(Scarborough, ME)

Poet's Note: Because we've written close to 20,000 poems over the last four years, it's easy to forget that, for most people, getting a poem is a totally new experience. Their initial reactions can range from curious, hesitant, to not even sure what's going on.

We had a gig one morning at a small coffeehouse in South Portland, called CIA Cafe. A church group regularly came to the cafe, and today was their day. Ninety-five-year-old Frances Smith was part of the group.

When Frances went to the counter to order, the cafe owner pointed to our sign and said, "Frances, did you get a poem yet?" Frances told her no, and seemed doubtful of the whole thing.

But, after awhile, Frances finally did walk over, and sat down across from me.

"How does this work?" she asked.

"I'll write you a poem about anything you want."

"Oh. Well, my name is Frances." She said it matter-of-factly, like that was all I

needed for a poem.

"Hi, Frances," I said. "I'm Sean. Is there anything you want to tell me about yourself for your poem? Maybe things you like?"

"Well . . . I like to dance. Or at least I used to. I'm ninety-five, so I don't really dance anymore."

I nodded and started typing. When I gave Frances her poem, she read over it, then smiled for the first time since she'd sat down.

"I like it," she said. "I really like it."

Later, the cafe owner told me, "Frances brought her poem up to the counter, all smiles. Then she went and showed it to her friends and they were all huddled over, reading it together like a group of young girls."

Afterward, Frances even sent me a photo of her feet.

FOR FRANCES

You may not know it
Just from looking
But these feet?
Oh these feet are full
Of music
Full of toe-tapping rhythm
Full of ~~floor~~ floor-sweeping turns
Full of dips and twirls
And gliding magic
Yes you might look
And just see these feet
Sitting here
Silently
But oh
Inside
These feet
Just like me
Are always
Always
Dancing.

typewriterrodeo
.com

Custom
Poems

—Sean

The Importance of Creativity

So many exams

on rote memorization

applying formulas

diagramming verbs

But it turns out

the best knowledge for life

can't be memorized

It has to be discovered

uncovered

inspired

adventured

Giving our brains the space to invent

Makes everything

more

more success

more joy

more quality

and more of the ideas

that make this world

a magical place

JODI:

THE IMPORTANCE
OF CREATIVITY

Poet's Note: Sometimes I write a poem that really captures my worldview, and what I hope to teach my kids, and myself.

typewriterrodeo.com

Custom Poems

jodi

152

DAVID:

RESILIENCE & HOPE

for Bella LaVey

(Austin, TX)

Bella: I received a stellar poem by David at the Writers' League of Texas Agent and Editors Conference. I'm going through a really hard time and the poem is my life line right now, a beacon, a beckoning. Thank you.

I know Typewriter Rodeo serves the community with inspiration and joy, but it's valuable to also show how this lovely creative service has the capacity to weave words that heal and hold. Your poem really anchors me in hope and resilience. Writers healing writers.

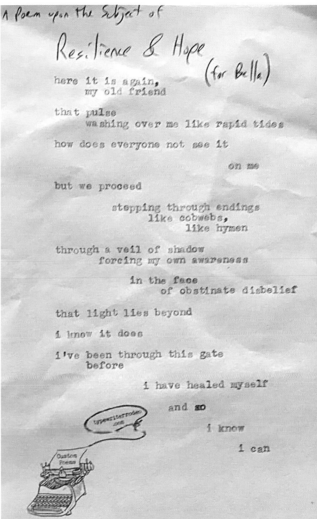

A Poem upon the Subject of

Resilience & Hope

(for Bella)

```
here it is again,
     my old friend

that pulse
     washing over me like rapid tides

how does everyone not see it

                         on me

but we proceed

          stepping through endings
               like cobwebs,
                    like hymen

through a veil of shadow
     forcing my own awareness

               in the face
                    of obstinate disbelief

that light lies beyond

i know it does

i've been through this gate
     before

          i have healed myself

          and so

               i know

                    i can
```

-d.

KARI ANNE:
SPARE HAIR
for Emma Virján

(Austin, TX)

Emma: I saw the Typewriter Rodeo booth and poets at the Texas Book Festival. Actually, I heard them before I saw them. I learned to type on a manual, so the clacking of the keys was alluring. I was a featured speaker that year (2015) and was reading from my *PIG IN A WIG* early reader series. I wear a red, Texas-big wig as I read from the books, hence the topic request of "Spare Hair."

I had been featured at the festival before, but this was my first time to read from the *PIG IN A WIG* series. I was excited. And a little nervous.

". . . today is the day/the day your real self/will explode forth/from the top of your head . . ."

Those words went right to my heart. They empowered me. My spare hair felt taller.

The poem is kept on my wall, next to the first proportion wheel I ever owned and a candy wrapper from chocolate I bought while visiting Versailles. The image on the wrapper is that of a spare hair queen herself, Marie Antoinette.

"Spare hair"

sometimes you're just feeling it
you know
today is the day
the day your real self
will explode forth
from the top of your head
all the fluff
all the growth
all the excitement
becomes a mushroom cloud of you
your spare hair
a world expanding
all on its own
your thoughts
and dreams
contained
in your growing
growing
mane

post your poem!
#typewriterrodeo
@typewriterrodeo

Marie Bouvero
l'amour du chocolat

MARIE-ANTOINETTE
REINE DE FRANCE

Chocolat au Lait
Milk Chocolate

SEAN:

JEANNIE

for Jeannie Dunnigan
Owner, CIA Cafe

(South Portland, ME)

Poet's Note: Our typical poem process works like this: Person comes to our table, gives us their topic, we write them a poem. For this one, however, it was more of a request by a whole group.

One morning, Jeannie had us come write poems for customers at her

coffeehouse in South Portland, Maine. Jeannie's cafe is a cozy gathering place for many of the locals, most of whom know her.

So, while I was getting out my typewriter, and before the poetry table was even set up, one of them called out, "Write one about Jeannie!" The rest of the cafe cheered, "Yes!"

Right then, Jeannie was delivering food to a table—on roller skates. And, so, that was her poem.

Jeannie: I'm always working—I don't always think of how others perceive me. But I know some of the customers enjoy the roller skates. A couple years ago, two of our regulars, Leland and Dave, peeked in the back kitchen door. "Nope, she don't have 'em on," Leland said. And they both turned and left.

The poem caught me in such a beautiful way—it brought tears to my eyes, made me feel appreciated. Because really that's my goal, to try and bring happiness to at least one person every day.

JEANNIE

Oh she rolls in
 Not like the fog
 But more like the sun
 On wheels
 A dash of xh cheer here
 A cup of joy there

And a whole plateful of laughter
 All around
And
 No matter how gray or gloomy
 It is outside those windows
 In here
 With her
 The day is always brightly
 Rolling
 Along.

"Indianapolis"

It's not really so far north
unless you're in Texas
It's not really so far
unless you're in Texas
there's a pretty cool race track
or there was at smepoint
I'm not sure
because, you know... Texas
but Indianapolis
you have your own charm
I know you do
I mean, you're no Texas
but your zoo is fantastic
and one day
we'll all look back and we'll say
wow
Indianapolis
it's no Texas
but it sure is swell

KARI ANNE:
INDIANAPOLIS
for Eva Olson &
Bernie Carreno

(Indianapolis, IN)

Eva & Bernie: We chose "Indianapolis" as the topic of our poem—it is the city we will live in together after decades of living apart.

We met and fell in love in college (in Milwaukee) back in the '70s. We drifted apart, married other people, and went on to live and work in many other cities (Seattle, Miami, Pittsburgh, New York, Nashville, Montreal, Chicago, Sydney, Rio de Janeiro, and Chattanooga—to name just a few). When we reconnected in 2010, Bernie was living in Indianapolis, but moved to Austin so we could be together. Now that Eva is retiring, we decided to move back to Indianapolis—where we have friends and resources for Bernie's life as a sculptor.

Indianapolis may not seem like a romantic destination, but for us it is. The poem captures the spirit of adventure and fun that we want to keep in our lives!

KARI ANNE:
A POEM ABOUT NOT WANTING A POEM

Poet's Note: Sometimes, people just don't know what to make of us. They circle the table, they stand at a distance, they wander over and then run away when we ask if they want a poem. Men, in particular, will scoff. They don't want a poem! A poem?! Isn't that . . . childish? Girly? How could a MAN want a POEM? Impossible! (Except, by the way they eye the typewriters, and by the way they keep coming back to check things out, we can tell they probably *do* want a poem, they just can't find a way to ask for one.)

We were typing at a corporate event for PayPal, and one of the service staff at the hotel was shark-circling our table. I asked if he wanted a poem, and he laughed, "No way!" But then he came back. "Ready for your poem?" Another laugh and a dismissive wave of his hand. A little while later, he circled back around, eyeing us.

"Hey," I called to him, "I know you don't want one, but I wrote you a poem anyway. It's about not wanting a poem." This time his laugh was genuine as he literally ran to get the poem. He kept laughing as he read it. "No one has ever written me a poem before!" he exclaimed. "I'm putting this in my locker. I'm going to read it every day."

Yeah. I knew he didn't want a poem.

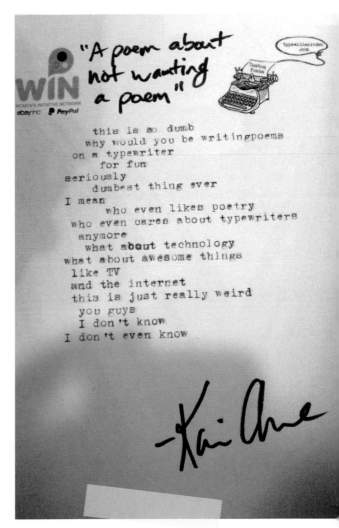

"A poem about not wanting a poem"

this is so dumb
why would you be writingpoems
on a typewriter
 for fun
seriously
 dumbest thing ever
I mean
 who even likes poetry
who even cares about typewriters
 anymore
 what about technology
what about awesome things
 like TV
and the internet
this is just really weird
 you guys
 I don't know
I don't even know

—Kari Anne

SEAN:
CARAVAN OF LIFE

Poet's Note: Every once in awhile, we'll snap photos not just of the poems, but of the people requesting them. But, just like the poems, once they leave, we have no idea who they are or where they've gone.

At the 2015 Texas Book Festival, a young woman gave me this topic: "I'm driving all across the Americas in my blue Dodge Caravan—I've been to Canada and across most of the U.S., then going down to Mexico and South America. I'm looking for a place to stop and call home."

She let me take a photo of her after she read the poem, but I never saw her again.

CARAVAN OF LIFE

You may see me (if you're lucky)
 Driving through your town
 Just me and my blue
 Dodge Caravan
But don't blink

 Because I'll be moving on
 Tomorrow
 Maybe even tonight
From the wilds of northern Canada
 To the salty shores of the Pacific
 Northwest

 Then across the heartland
 The badlands, ewen, of South Dakota

 And up and down the east coast
 Teeming and crowded

 With cities and life
And soon I'll turn south
 To those other Americas
 Central and the great wide South
 Yup, there I go, a streak of boxy blue
 Me and my Dodge Caravan
 Exploring and living
 And all the while looking
 For a home.
 And if you're lucky you'll see me
 Driving through your city

 And
 If you're even luckier
 Your city might be the one
 Where I stop.

typewriter roder
is in the horse
we will write you porms
until you larf and larf
sometimes we'll even
make you werp
that's how good our porms are
so sterp right up
and give us a word or phrase
we will give you a porm
that will save your day

L TECHNOLOGY MINI-WIN EVENT | NOVEMBER 11, 2014 | AUSTIN

TYPEWRITER RODER

KARI ANNE:
TYPEWRITER RODER

Poet's Note: Putting on a huge corporate event is not an easy task. Sometimes, mistakes got made. But much like writing on a typewriter, when a mistake happens in the flurry of a corporate event, you just have to go with it. Like we always say, the typos are free.

At one particular event, the sign leading everyone to the Typewriter Rodeo table had a glaring typo. We found a Sharpie to fix it, and then enjoyed teasing the event coordinator to the point where she fell on the ground laughing.

She learned an important lesson that day: Sometimes the typos are the best part.

typos are free

SEAN:
ROOTS

for Melanie Bennett Jacobson

(Rancho Santa Margarita, CA)

Melanie: Last summer I stood in a stuffy little gallery on campus at the Vermont College of Fine Arts where I was browsing integrated poetry and art projects made by my classmates in my masters program. Sean was there offering up poems, and so I got in line and spent the next fifteen minutes thinking about what I wanted the poem to be about.

I entertained and discarded several ideas from the silly to the pretentious, but ultimately the right word came to me in a little glow of peace. Residencies in this graduate program are often grueling, exacting an emotional tax toward payment on professional growth, but they also show writers what they can become. And as I sat there thinking about how much I had grown, I thought too of how proud my parents and grandfather would be if they were still alive to see what I'd chosen to do with my life.

When it was my turn, I stepped up to the typewriter and offered only a single word without the context: roots.

This poem was the result, and when I read it, I couldn't believe it. My parents, dead ten years, showed up in the last lines. Sean didn't know who or what I had been thinking of when I requested the poem. But there they were, the roots I grew from.

Now as my own roots grow and my first child heads off to college in a few weeks, I'm dealing with it by turning his room into my office where I can escape to write stories. And this poem, this piece of unexpected magic, this token sent to me by my long gone parents one summer night through a stranger, will sit by my desk to encourage me for the rest of my life.

ROOTS

It's crazy
 You can't see them

 But you know they're there
Perhaps right there
 Under your very feet
 This moment
And how far down
 Do they stretch?

 Perhaps one layer
 A single generation

 Or perhaps too deep
 To ~~even~~ even know

 All the way back
 And down
 To ancient ~~~~ history

But always
 Always
 They are there
 Unseen
 And supporting you
 With every
 Single
 Step.

typewriterrodeo
.com

Custom
Poems

—Sea

Female Bookseller

The magic of a particularly incredible find

 The perfect smell

 The crispest leaves

 The signature, slicked across the page

 A note to a friend, beloved

Now shared with the book lovers and book sellers
 The collectors and seekers

And we,
 the few
 the women who corral the books
Trust us with your most precious finds

 Trust us to uncover the most exquisite editions

 And mostly--
 join us.
 Come join the ranks of the

 women who love books

 Let's dive into our new favorite read
 together

-jodi

Washington
Antiguarian
Book Fair
www.wabf.com
2016

JODI:
FEMALE BOOKSELLER

for Sunday Steinkirchner

Owner, B&B Rare Books
(New York, NY)

Poet's Note: It's always been a hidden dream to own a bookstore, to spend my days among the collection, to help gift readers with their newest favorite story. I spent so much of my teenage years cozied up in corners of bookstores, discovering worlds and gently paging through antique printings. Typing poems at the Boston

I'M CEO, BITCH

and Washington Antiquarian Book Fairs has been an amazing way to connect with the rare book world. I loved getting to write this poem for Sunday.

Sunday: I requested this topic because I've been in the rare book trade for almost thirteen years now, and there certainly are not many female booksellers out here. We have been in the minority for so long, and the few of us have long suffered harassment by other members. When I requested a poem on this topic, a Code of Conduct was being introduced to our national bookselling organization—discussion of it had begun and I was shocked at how many members didn't support it and claimed that sexual harassment is not a problem in our trade. Although I rarely join the online listserv discussions, I felt it was time to weigh in on the many unpleasant experiences I've had. Other women joined in, and with support for the code growing, it ended up passing! Nothing revolutionary, the code was general language that has been used in corporate settings for about forty years, but it certainly helped update our "antiquated" trade standards of behavior.

Reading this poem, I take pride in the fact that I am, indeed, a bookseller.

Cynthia and Kekla

CASA CYN

They say in life few things are tougher
 More stressful
Than switching places, moving to a new
 Home
And yeah it can be scary
 Work and toil and time-consuming
 But once it's done
Once you're there and in your new casa
 Filled with your stuff
 Books and pictures and all the things
 That make you
 YOU
 Once it's like that
 And then you bring in friends
 To visit of even stay a few days
That's when that stress falls away
 When that place takes on its own life
 When that place turns into a true
 Home
 A true ~~reflection~~ reflection
 Of you.

Post Your Poem!
@TypewriterRodeo
#TypewriterRodeo

SEAN:

CASA CYN

for Cynthia Leitich Smith

(Austin, TX)

Cynthia: Dear pal Kekla Magoon had journeyed from Vermont to visit (and help!) as I unpacked and set up my new condo. She'd been a bright light and comedic relief throughout the relocation busy-ness and stress.

Kekla and I had joyfully abandoned our mission so that we could go celebrate the release of a picture book, author-illustrator Don Tate's "Poet: The Remarkable Story of George Moses Horton," at the George Washington Carver Museum and Cultural Center in Austin.

In the lobby, beyond the custom book-cover cake and growing crowd of bookish Black history enthusiasts, Kekla and I spotted Sean, plucking at his manual type keys. We rushed over and requested poems for each other. She ordered one for me with the title "Casa Cyn." It's now framed and hanging in my new home.

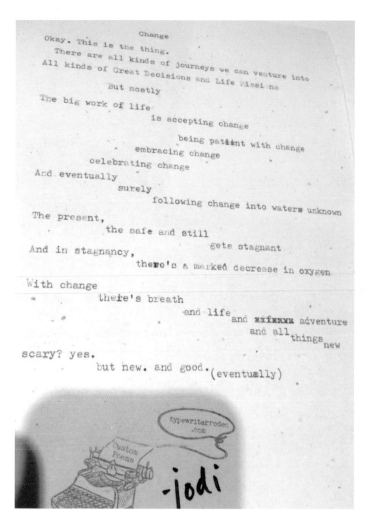

JODI:
CHANGE

Poet's Note: I get a lot of requests for poems about transitions. Change is hard. But it's also so necessary, and so good. And it's something I never get tired of writing about.

THANKS, OBAMA

No, you don't get to use that anymore
 Haters
You've got your own Hater-in-Chief
 Coming in.

So now, that phrase can finally
 Tearfully
 And truthfully
 Be used:
 Thanks.

For giving us hope
 When our light seemed dim
For giving us eloquence
 Amidst a shouting sea
For giving us peace
 The rarest of role models
For giving us freedom
 To work, live, and love
 How we wanted
For giving us all you had
 Of you.

We will miss it
 That quick wit
 That calm reserve
 That steel fist, when needed
 That smile too
 And above all that towering grace
That made us all
 Proud.
And so
 What is left?
 But to wipe a tear
 And say
 Simply
 And never enough:
 Thanks.

typewriterrodeo.com

Custom Poems

— Sean

SEAN:

THANKS, OBAMA

Poet's Note: During and after the 2016 presidential election, we got lots of political poem topics. This one was for a social media post, written on President Obama's last day in office.

"Writing the words"

```
        here's the thing
      you ca n fucking write
    you can be
        a fucking writer
      the words are in your h ead
      they belong to you
  anyone else who reads them
        is only an interpreter
        only skimming the sur face
        of everything
      deep inside you
      so think about that
          when the paralysis hits
      when the blank page
    is a wide open maw
  silently screaming at you
    think a bout how the words are yours
    they are fucking yours
        to do with
  as you may
```

KARI ANNE:
WRITING
THE WORDS

Poet's Note: People very much want to know what the secret is to being able to write spontaneous poetry for hours at a time. "Don't you got writer's block?" they ask. "How do you come up with so many ideas?" The prevailing assumption is that we must keep half-written poems in our heads all the time, or re-use stanzas, or something like that. The truth is (and this is what we tell everyone who asks) the person requesting the poem has the most difficult job of all . . . *they* have to think of the topic. Once we have a topic, ideas and word choices are endless. But if we had to sit in front of our typewriters for hours and come up with subjects? THAT would be difficult.

We don't get writer's block, because we don't have time to get writer's block. You come up with the topic, and we have to get started—boom—because there's a line behind you and poetry to be written. There's no time to worry about whether the poem is perfect, and there's no way to go back and fix typos. We just write. And so, when people ask how we do it, when they want advice for their own writing, that's what we tell them: Just write. The words are already in you, all you have to do is let them out.

171

SEAN:

CARTOGRAPHY

for Judith Smith

(Austin, TX)

Judith: I didn't really have a topic the night the Rodeo came to town. I wanted my experience to be spontaneous, so I never considered what topic to choose. On Rodeo night Sean happened to compliment me on my compass rose tattoo, and I guess that's why I asked for a poem about cartography.

You see, I am a map maker and map lover and maps have been part of my life since childhood, when I collected gas station maps on long travels across the USA with my family. In college I studied cartography before maps became digital; we used pens and papers and many other tools to craft maps by hand. My career as a cartographer opened my eyes to places I had never been and nowadays travel is a major part of my life. I still love collecting and displaying maps and I also use them in my artwork. A few years back I decided to add a compass rose on my arm—so I will always find my way in whatever world I find myself.

The poem Sean wrote really captured how I feel about maps, and the journeys I have been on with them and without. I've searched for ancient globes and maps in many countries, and they always remind me that there is something waiting on the next horizon. Even though I know and love the map as art object, travel tool, and record of history, there is no true map for one's life.

We create our maps as we go.

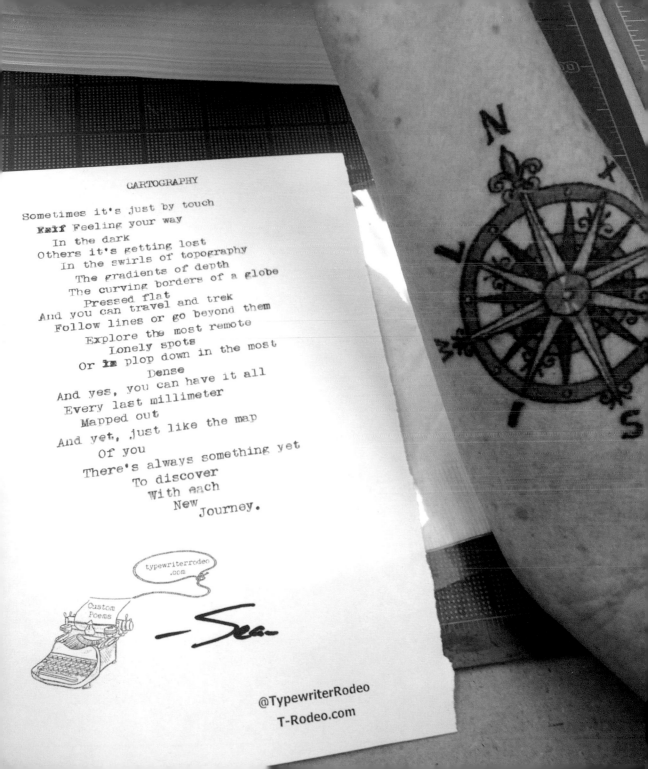

CARTOGRAPHY

Sometimes it's just by touch
~~Feli~~ Feeling your way
 In the dark
Others it's getting lost
 In the swirls of topography
 The gradients of depth
 The curving borders of a globe
 Pressed flat
And you can travel and trek
Follow lines or go beyond them
 Explore the most remote
 Lonely spots
 Or ~~in~~ plop down in the most
 Dense
And yes, you can have it all
 Every last millimeter
 Mapped out
And yet, just like the map
 Of you
There's always something yet
 To discover
 With each
 New
 Journey.

typewriterrodeo.com

Custom
Poems

—Sea—

@TypewriterRodeo

T-Rodeo.com

BELIEVE

It's weird how in this time of year
 We tell kids to
 Believe
 But forget to tell ourselves
 The same thing

Because sure, kids need it
 But oh oh
 OH
 So do the rest of us

 And it's there if we just look up
 On a clear cool night
 At those countless sparkling stars
 All blinking, winking at us
 As if to say, "We're here. We KNOW.
 And it will all be
 Okay."

All of them up there, like a blanket of light
 Life
 And love

And in the daytime
 When you look up
 Sure you can't see them
 But they're there just the same as always
 Always

 If you only
 Believe

love,

Sean 12-24-15

SEAN:

BELIEVE

for Jennifer Murphy

(New York, NY)

Jennifer: Believe. It has always been my "POWER" word. A word I have prayed on. Passed on. Lived by. BELIEVE has always been my truth—something I have trusted in as my life took various twists and turns. I believe in the power of people. I believe #EHFAR (Everything Happens For A Reason) and I believe what you put out in the universe comes back to you, not always as you've wished for but as you need it to arrive, including a personalized poem from a friend I hadn't seen in nearly 30 years.

When Sean and I reconnected, I knew it was a powerful homecoming . . . not only because of my fond memories of him helping me pass trigonometry during my senior year of high school but because of his gift of the word—and taking ONE word and writing something that had so much depth and meaning behind it. When I lobbed him "BELIEVE," he interpreted, so perfectly, what it has meant to me and means to me. It was especially timely during the holidays when it is easy to lose sight of one's truth and what we are holding out for. For me, it was love. True

love. I wasn't looking, I was just believing that there was a bigger plan for me and I had to trust and believe that I couldn't see what was in the making.

As I continued to thrive in most every area of my life, professionally and personally, love eluded me. I didn't fret, I didn't worry. I was actually quite at peace with my journey and believed that I was on a winding road, a road that I owned no map to, had no control over, one that twisted, turned, had cracks, speed bumps and, sometimes, open roads so far that I could not see where it was going. Receiving the poem was a true gift; something I will forever treasure; a signpost that said, "Keep going. Keep believing. You are exactly where you are meant to be."

And, since getting the poem, I reconnected with another old friend, and found true love. And I continue to Believe.

You like chocolate
For me, vanilla
But both of them are sweet
Sometimes it's sweet
And super good
Sometimes a rocky road
It don't matter what
We might love
I never want it to stop
But just one thing
A favor, love:
Like the cherry
Can I be on top?

"THE
CHERRY
ON
TOP"

poems
on the
FEISTY
SI-
D-
E

SEAN:

LOVE & ICE CREAM |
HOUSE-HUNTING NEWLYWEDS

for Allison & Alex Elium

(Austin, TX)

Poet's Note: As a rough guess, we think we've written nearly 20,000 poems in the last four years. So, of course, we only remember a fraction of them. And even rarer is to run into people we've written poems for. But, sometimes, both happen.

Poet's Second Note: It can be hard to tell whether a complete stranger will be offended if you drop an f-bomb in their poem. So, when I feel like I'm headed in that direction, I'll stop typing and ask, "Do you mind if I swear in your poem?" Most times I get a solid "yes" or even "Fuck, yes, please do!" But if they pause for even a moment, that's a no. There was no pause when I asked Allison and Alex.

Allison: We discovered the Typewriter Rodeo at the Thinkery Museum on our first Valentine's Day together. We both love poetry and anything antique, so we were immediately pulled in by this fascinating concept. When Sean asked us to give him a topic, we chose *love*, and then to make things more interesting, I added, ". . . and *ice cream*!" We waited excitedly as we watched Sean smiling, laughing, and typing away. We LOVED our poem and were especially tickled by the clever ending line. Alex framed it as a gift that year, and it has been in our living room ever since.

We ran into Sean again about three years later. This time, instead of celebrating our first Valentine's Day, we were celebrating our first month of marriage! We immediately began telling him about the poem he'd written for us back in 2014. To our surprise, he remembered us and even remembered the last line of our poem!

This time around, we asked Sean for a poem about being newlyweds looking for our first house together. Once again, we loved our poem. And once again, it ended with a sassy last line. Sean wrote the poem on a Thursday night and we

178

HOUSE-HUNTING NEWLYWEDS

Oh it's a crazy task
Finding a new home
The prices just get higher
Wherever you roam

You could go way north
Or super far south
And maybe it's affordable
About 100 miles out

I mean, you just blink
And that that great house is gone
And there's nothing to do
But just soldier on

And someday, soon
We'll find one, with luck
But for now, screw those prices--
Let's just go fuck.

You like chocolate
For me, vanilla
But both of them are great
Sometimes it's a sweet
And syrupy good
Sometimes a rocky road
But no matter what
The flavor, love
I never want it to stop
But just one thing
A favor, love:
Like the cherry
Can I be on top?

found our house that Saturday!!! We closed on it a month later and framed the poem as the first piece of art in our new house. Typewriter Rodeo has a very special place in our hearts!

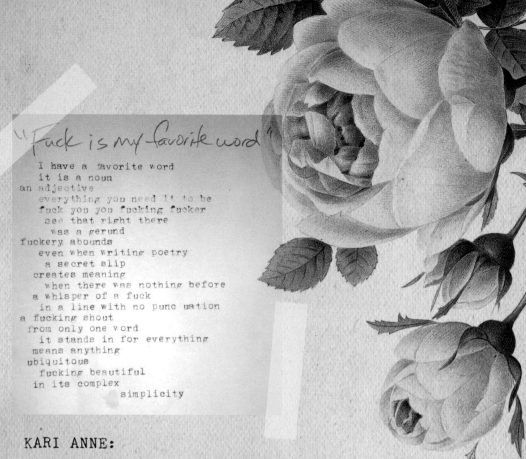

"Fuck is my favorite word"

```
    I have a favorite word
    it is a noun
an adjective
    everything you need it to be
    fuck you you fucking fucker
    see that right there
    was a gerund
fuckery abounds
    even when writing poetry
    a secret slip
  creates meaning
    when there was nothing before
a whisper of a fuck
    in a line with no punc uation
a fucking shout
 from only one word
   it stands in for everything
 means anything
ubiquitous
   fucking beautiful
 in its complex
                simplicity
```

KARI ANNE:

FUCK IS MY FAVORITE WORD

Poet's Note: We find ourselves typing poems in a lot of surreal places. One of these places was a quiet bar hidden in the back of the Westmoor Country Club on Nantucket Island. It was late at night, it was a Monday, and the crowd had thinned.

A woman in her mid to late forties approached me, and it would have been easy to make assumptions, based on her appearance, and based on our location. But, as poets and interpreters of the human condition, we've learned never to assume, and always to listen. She smiled at me, leaned over my typewriter, and said, "Fuck is my favorite word." I told her it's definitely in my top five. And for just that moment, the two of us, who might never have crossed paths in our lifetimes otherwise, shared a quiet moment of reverie and camaraderie.

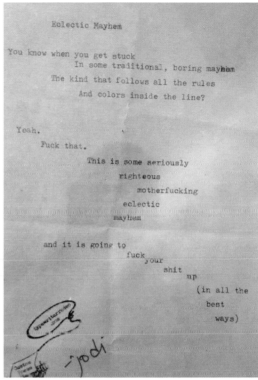

Eclectic Mayhem

You know when you get stuck
 In some traditional, boring mayhem
 The kind that follows all the rules
 And colors inside the line?

Yeah.
 Fuck that.
 This is some seriously
 righteous
 motherfucking
 eclectic
 mayhem

and it is going to
 fuck your
 shit
 up
 (in all the
 best
 ways)

—jodi

JODI:

ECLECTIC MAYHEM

for Windy Bowlsby

(Austin, TX)

Windy: I have a very good friend (we are co-shenanigators) who also loves movies and adventures and being open to awesome new things (like movies at Fantastic Fest). Somewhere in the beginning of the Festival, we were dubbed by another friend "the Eclectic Mayhem" and we thought that sounded excellent. We want to gather new and disparate ideas and experiences, and we are not above a little mayhem to do it.

When Jodi asked for a poem topic and I said, "eclectic mayhem," I remember her eyes lit up and her fingers started flying. It was amazing—how quickly the poets can gather ideas, start creating, and even consider the formatting of the poem. One of my favorite poets is e.e. cummings and so I love the formatting and the parentheticals, natch.

And the poem? Absolute joy. It expresses one of my core beliefs so perfectly ("fear is never boring" or "you have to be willing to fail in order to find adventure" or even simply "why the fuck not?").

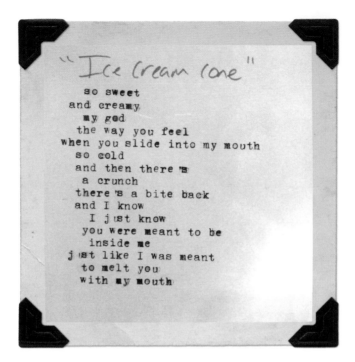

"Ice cream cone"

```
     so sweet
  and creamy
    my god
   the way you feel
when you slide into my mouth
   so cold
   and then there's
    a crunch
   there's a bite back
   and I know
    I just know
   you were meant to be
    inside me
 just like I was meant
   to melt you
   with my mouth
```

KARI ANNE:

ICE CREAM CONE

Poet's Note: We get requests for food poems a lot. Not as often as pet poems, but close. What people don't realize, though, is that their food poem, if written by me, will be dirty. It's a theme I can't shake. The poems are always different, but they always have a dirty twist. Maybe I need a typewriter poet/therapist to explain why. Or maybe I don't! Just know . . . if you ask for a food poem, it's not going to be an all-ages poem.

This particular poem request came from a woman at an outdoor festival. It was a hot day, she was eating ice cream, the topic was an easy decision. When I handed her the poem, though, her eyes widened and her cheeks reddened. "Um, thanks?" she said, laughing. I shrugged and laughed with her. "At least you didn't ask for a poem on nachos. . . ."

Library Lover

Oooh girl

 I just wanna slide between the history and
 American studies sections
Tuck on in where the aisles are clear
 And take a good deep whiff
 of your musky misty leaves

Hold you all gently

 Not gonna crack your spine
 But flip the pages
 Flip the sections
 Flip you over to read the acknowledgements
 in your heart

 I'd like to run my fingers
 Along your dewey decimal

 And
 I'll never leave you
 unsorted on the shelf

JODI:
LIBRARY LOVER

Poet's Note: Sometimes the poem topic and the mood of the day just combine into some smolder. Do I love libraries? Perhaps a bit too much.

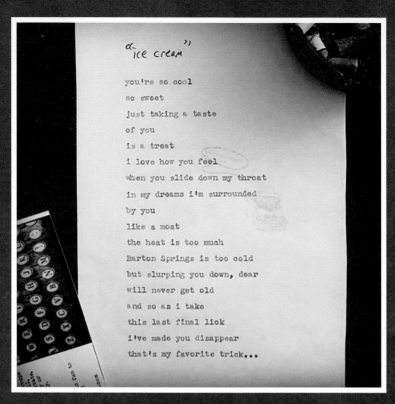

DAVID:

ICE CREAM

for Emma Kalmbach

(Austin, TX)

Poet's Note: Sometimes the muse just slides up, gives you a friendly lick, and takes over.

```
         "Piano"

     I can play you soft
     I can play you hard
     tickle your keys
        or just lightly caress
   I can bring forth  sounds
        no one has heard
     I can create melodies
   from you
        only you
           that will make people cry
           your keys
        are me
           an extension of everything
           my mouth can't say
     my tongue can't sing
        you, right now,
           are my everything
```

KARI ANNE:

PIANO

Poet's Note: Two young men, clearly in love, came up to me at a museum event in Houston. They could barely tear their eyes off each other long enough to ask for a poem. When I prodded for a topic, they were stymied at first, then I got a big smile. "He plays piano," the man on the left said. "You've never heard anything like it." The man on the right blushed and was about to protest this compliment. I held up my hand. "Don't say anything else. Your poem is writing itself."

Last Week o' My Thirties

It's hanging out there like those cool girls in high school
Looking all chill and sure of themselves

But we all know they're insecure inside
$ 40. til they know how much
 they rock as themselves
Just waiting for me to xixxi sidle up and say hey.
Oh and guess what?

Turns out that the last week of thirties is a perfect time
To shake loose of some long held gripes
And release all the nagging worries

Because here's the truth

40? She is the best new bestfriend you didn't even know
you wanted to meet

She's giving no fucks

She's all thoroughly herself

And she's having so much fun

Have a lovely time, thirties, it's been fun
But I'm ready to go hang with 40s.
And it turns out that 40s are super ready
To have a blast hanging with me

JODI:

LAST WEEK

O' MY THIRTIES

for Gretchen Du Prè

(Austin, TX)

Gretchen: Celebrating the end of a decade and the beginning of a new one. Magical. A lovely surprise to run into Jodi doing her thing. And watch her in action. My reaction surprised me—happy, sweet tears and catching my breath. It perfectly captured how I felt anticipating the beginning of my forties.

I feel like it was Jodi's birthday gift to me. And it's a framed treasure on my bedroom wall.

What a super start to the last week of my thirties. Dim sum and Maker Faire with my boys plus the sweet surprise of running into Jodi and Typewriter Rodeo to get this magical poem.

The Most Fassbender of all Fassbenders

Look

There are a lot of hot human beings

On thisplanet of ours

And frankly, we are going to need them

And their waves of goodness

To guide us through the oncoming waves

So.

I am launching my vessel directly at the source

The Magnetoist
The dreamiest

the man who defines men

against whomx all others

are just..

not him.

You're the Pass who Benders my heartx

You bend my soulx

You fassten my songs

And together

hoowee

together we could change the

world

(call me, MF, call me)

JODI:

MICHAEL FASSBENDER

for Paulette Beete

(Austin, TX)

Paulette: I confess to being nervous standing in line waiting for my turn to get a poem, despite the soothing noise of typewriters. As a poet, I've always been terrified by the idea of "instant" or "occasional" poems, and I guess that was true even though I wasn't going to be the one writing the poem. I also felt nervous deciding what to ask for a poem about. I wanted to give the poets something interesting to write about, but not choose something so esoteric that I was met by blank stares.

Michael Fassbender is one of my favorite actors. Yes, he's gorgeous, but his talent far outshines his looks, the way he inhabits every single one of his roles—no matter the movie— with what feels like every fiber and pore

of his being. That's how I'd like to inhabit my poems, or at least, the writing of them.

And yes, the Typewriter Rodeo poem I received is the Fassbender poem I wish I'd written. Swoon. Sigh. Swoon.

The poem, of course, now lives above my writing desk to inspire me to write my own Fassbender poem or two.

187

SEAN:
SARCASM

Poet's Note: One of the coolest things is that we've gotten to spread the poetry love literally from coast to coast. From Nantucket, Boston, and New York, down to Texas and even Mexico, and out to California and the Pacific Northwest. This poem was from the 2017 Alki Art Fair, on a gorgeous beach in Seattle, when a guy came up and asked, "Can I have a poem on sarcasm?" No. I'd never write that poem.

```
            SARCASM
          (for Patrick)

Oh this poem
  This is the greatest
    Fuckingpoem
      Ever
  It's like the wordgods
    Themselves
      Have flown down and taken over
  My hands
I don't even know
  How I can stand
    To do it
  Just pounding out
  Pure
    Mistimake free
      Beauty
  And really
    The only thing
      More glorious
  Is when I look
      In the mirror.
```

Kari Anne:

I AM SO FUCKING CALM

Poet's Note: She had almost completely passed our table when I shouted after her, "Would you like a poem? It's free!" We were set up to type Valentine's Day poems in front of the University of Texas at Austin Co-op Bookstore. Most of the students who approached us ignored the fact that it was almost Valentine's Day.

They wanted poems about exams and roommates, and surprisingly a lot of them wanted poems for their mothers.

This young woman, though, was hellbent on not getting caught up in the small crowd around our table. Her friend had paused to see what was going on, but she was off. When I called after her, though, she turned and marched back to the table. She aggressively eyed the typewriters, me, the whole scene.

"Fine," she barked. "Write me a poem about being calm!" Her tone, her stance, her volume, her expression all screamed everything but calm.

So I wrote her a poem.

When I handed it to her, she snatched it from me and then her face transformed in slow-motion. She went from petulant to surprised to delighted to awed. She laughed and hugged the poem. She hugged *me*. She thanked me profusely. She skipped away. Two hours later, she came back and stuffed a ten-dollar bill in the tip jar. "I taped the poem up next to my bed so I can read it every morning and every night," she said. "I don't know how you did it, but it's perfect."

```
I am so fucking calm
   you don't even know
 the goddamn sunshine
    shines in my hair
    and fuck
  just fuck
    I am so fucking sere
I am so fucking calm
    this day
  will live
    in cocksucking
   infamy
      bitches
```

Jodi Egerton has a PhD in English from the University of Texas at Austin, and has recently published *This Word Now*, a creativity and writing craft book co-written with her husband Owen Egerton. Jodi is also a classically trained clown, a childbirth doula, a goat-milker, and an auctioneer.

♡ jodi

David Fruchter is a writer, editor, poet, and performance artist living in Austin. He is also the former producer and host of *Slappy Pinchbottom's Odd Preoccupation*, a long-running radio show in Austin that was devoted to the spoken word and other literary arts.

— david

about the AUTHORS

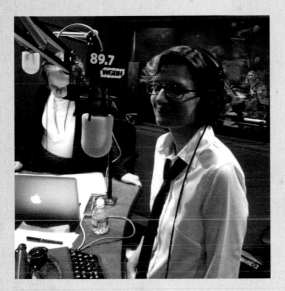

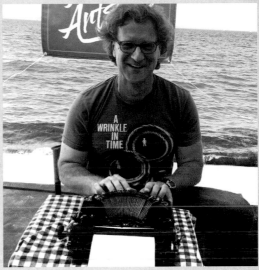

Kari Anne Holt is the author of several middle grade novels in verse including *House Arrest*, winner of the 2017 Mississippi Magnolia Book Award, a 2016 contender for the Global Read Aloud award, and a 2015 Nerdy Book Club award winner for poetry. Her book *Rhyme Schemer*, is an Amazon Best Book for Kids and Teens, and a Bank Street Best Book of the Year. She has also published several middle grade fantasy adventures, including *Red Moon Rising*, *Gnome-a-geddon*, and *Brains for Lunch: A Zombie Novel in Haiku!?*.

Sean Petrie loves writing, teaching, and donuts. He has an MFA in Writing for Children from Vermont College of Fine Arts and is represented in his fiction writing by The Erin Murphy Literary Agency. On the other side of his brain, Sean has a law degree from Stanford University and teaches legal writing at The University of Texas School of Law. He is a former member of Austin's ComedySportz improv troupe, and still thinks *Buffy* is the best show ever.

Jodi

David

Sean

Kari Anne

ABOUT THE TYPEWRITERS

As you might have guessed, we love typewriters. The combination of using them for on-the-spot poetry has been an unexpected joy, kind of like the old "you put your chocolate in my peanut butter!" commericals for Reese's Peanut Butter Cups.

Over the years, we've slowly learned how to care for, repair, and lovingly restore these beautiful machines. While we each now own multiple typewriters (some of us dozens!), here's a little bit about the main ones we use.

Jodi's saucy Litton: This Litton Imperial is from 1970 and had a long, luxurious previous incarnation at the hands of my mother-in-law, Judith. She's a family practice doctor who used the typewriter during her salacious stint as the medical adviser for *Penthouse Forum* in the UK in the early 1970s. This typewriter has seen a lot. And still performs admirably. Just like my beloved mother-in-law.

David's shifty Royal: This Royal Quiet DeLuxe is from 1941 and I obtained it at the wonderful Uncommon Objects shop in Austin. What drew me to it, and is still my favorite aspect, is a key in the lower right labeled "SHIFT FREEDOM." I like to think that key has multiple meanings, and pressing it can open up multiple worlds. And, much like donning my typing hat, when I sit behind this machine, I feel like I am shifting, too—into my free-flowing, poetry-producing self.

Kari Anne's trusty Oliver: This Oliver portable is circa-1950 and has some very interesting keys. Was it produced for accountants? Maybe a bank? The Oliver likes to spontaneously twist its ribbon, so you might get a poem written in black ink, or you might get one written in red. It's a mysterious quirk, but quite charming.

Sean's pop up Remington: This Remington Portable is from 1928 and is my go-to for most gigs, even though I have about thirty typewriters. (Who's obsessed?) I love that, when you're ready to type, you slide a lever along the side and the letters pop up like a row of peacock feathers. I love the feel of each key—so responsive and crisp. I love that it's from 1928 and still kicking. I love it so much, I made it my first (and currently only) tattoo.

PHOTO CREDITS